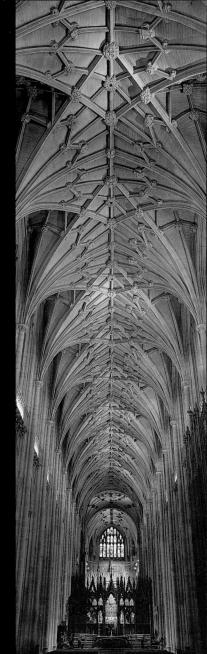

STRETCH

the world of panoramic photography **nick meers**

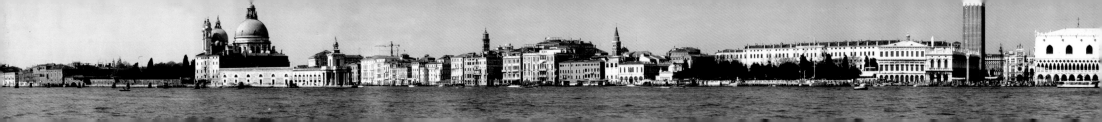

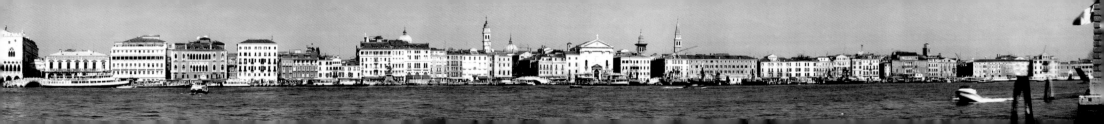

A RotoVision Book.

Published and distributed by RotoVision SA
Route Suisse 9
CH-1295 Mies
Switzerland

RotoVision SA, Sales, Production & Editorial office
Sheridan House, 112/116A Western Road
Hove, East Sussex BN3 1DD, UK
T +44 (0)1273 72 72 68
F +44 (0)1273 72 72 69
Isdn +44 (0)1273 73 40 46
Email sales@rotovision.com
www.rotovision.com

Written by Nick Meers
Designed by Red Design
Originated in Singapore by ProVision Pte. Ltd.
T +656 334 7720
F +656 334 7721
Printed and bound in China by Midas Printing

Cover photograph: Tibetan Snowfall. Drepung Monastery, Lhasa, Tibet
© Everen T Brown
p1: Winchester Cathedral, England © Nick Meers
p2-3: Venice Waterfront, 180 degrees © Michael Westmoreland
p4: Green Wildfire © Julia Claxton
p144: Lone Rock, Mauritius © Nick Meers

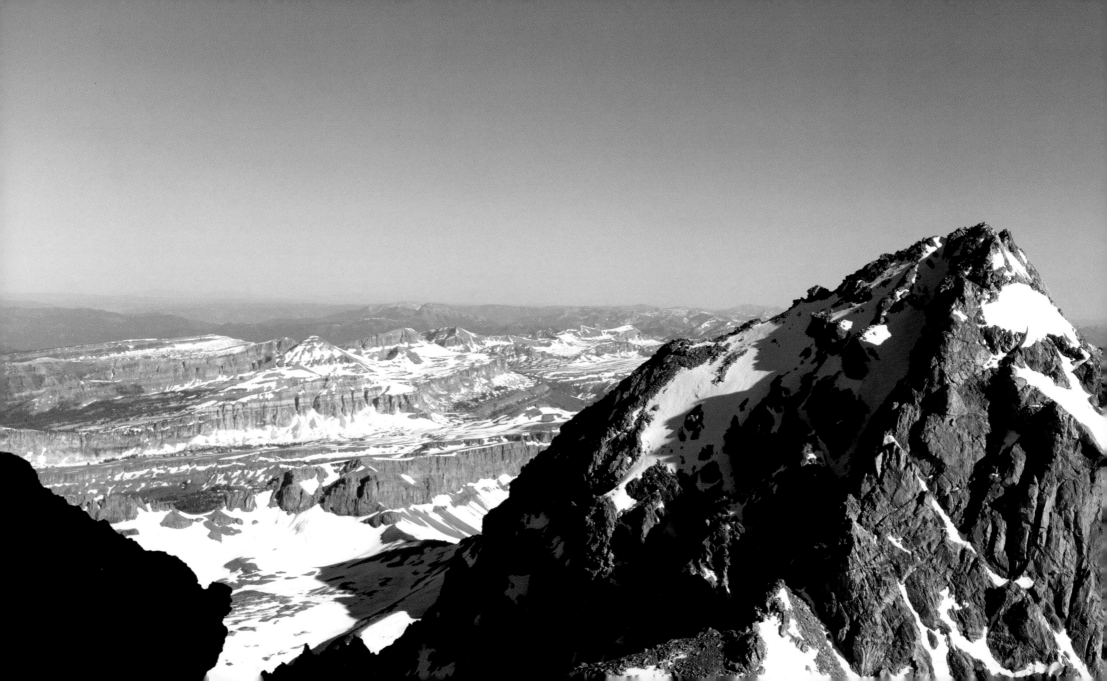

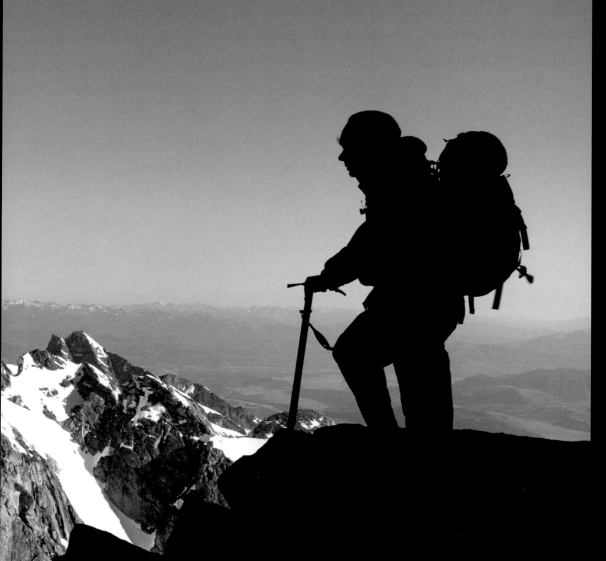

introduction

Welcome to the wonderful world of panoramas – a world full of variety, invention and fascinating engineering. There are as many interesting characters involved in panoramic photography as there are extraordinary photographs, for nearly every time a shutter is pressed, it is to solve a visual conundrum. Experiments have pushed the boundaries upward, onward and outward almost since the beginning of photography in 1839.

Those photographers who have experimented with, and continue to shoot, this most unusual of picture formats, all agree that a panoramic image retains a particular fascination, and many of them have spent years perfecting their techniques in a huge variety of disciplines.

In this book, we take a look at the basics of panoramic photography, its history, and the extraordinary cameras that are used to shoot this format. We also profile some of the world's finest practitioners of the art. Panoramic cameras have been used all over the earth's surface, sometimes at great risk and expense, to bring us unforgettable images that show us much more than a conventional photograph ever could.

Forget your preconceptions – panoramic photographs are no longer about lines of reluctant groups or faraway views of distant horizons. Instead, join us in an exploration of the king of unusual formats, the panorama.

Leo L. Larson
Hiker in Grand Teton National Park, Wyoming, USA
Fuji G617 camera
Agfa Scala b&w transparency film
© Leo L. Larson/Panoramic Images

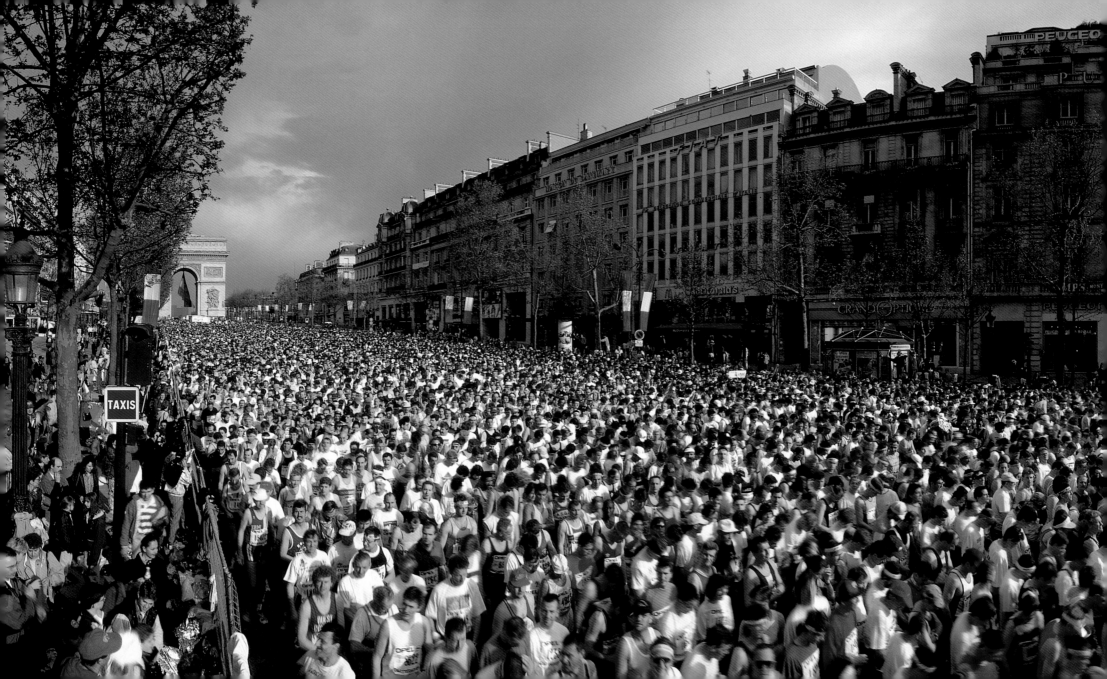

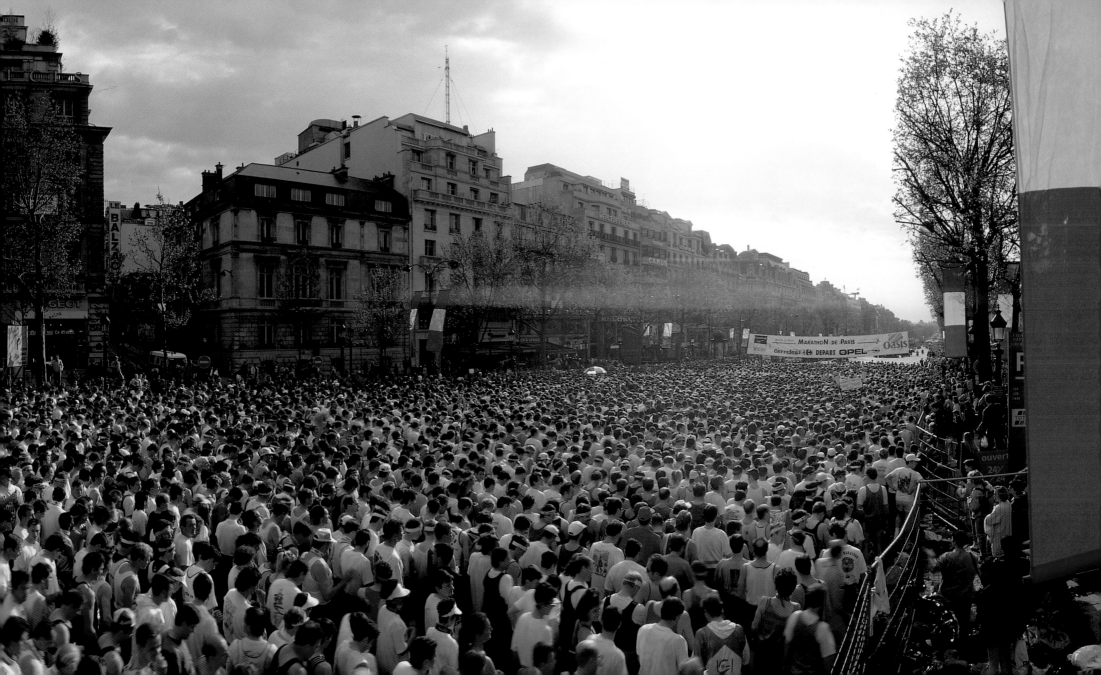

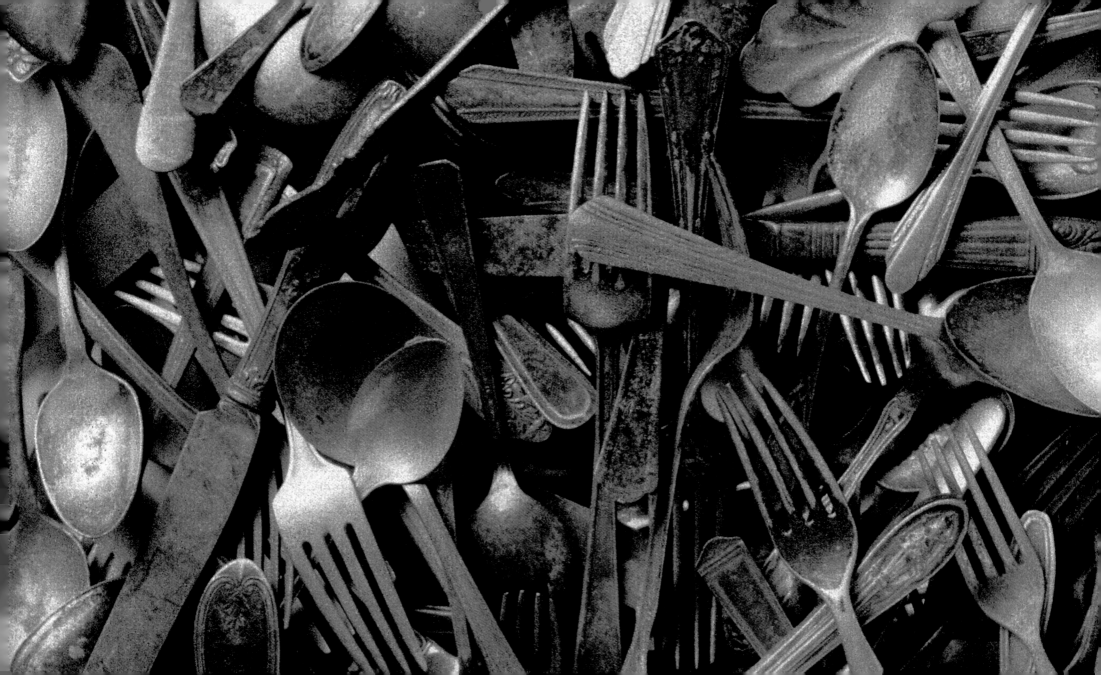

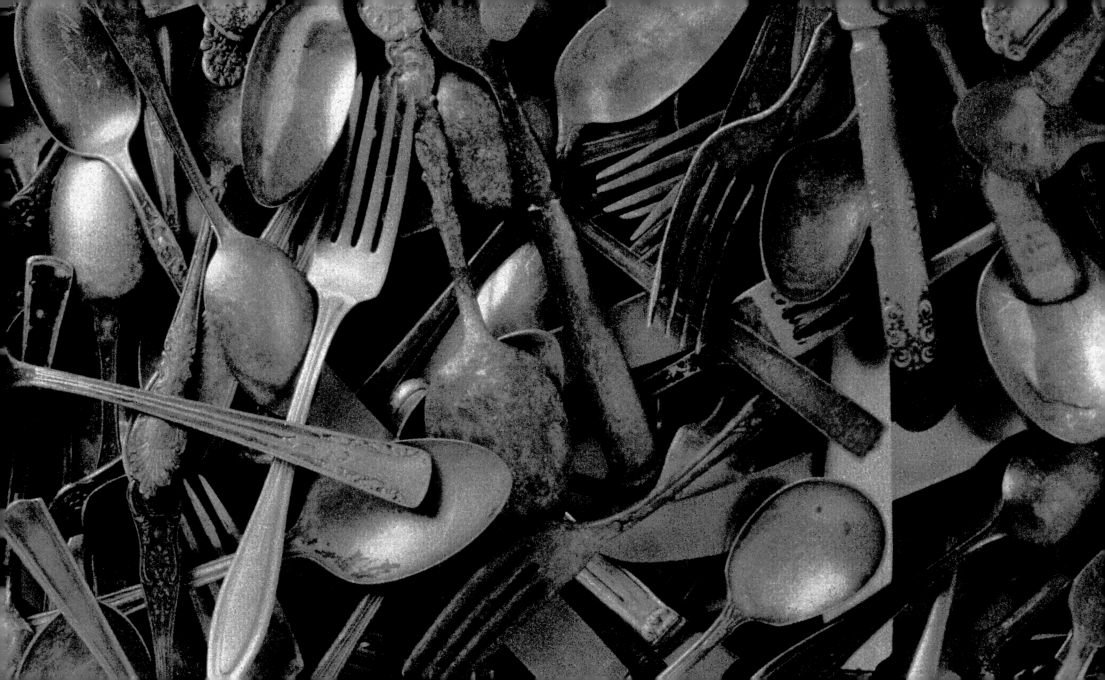

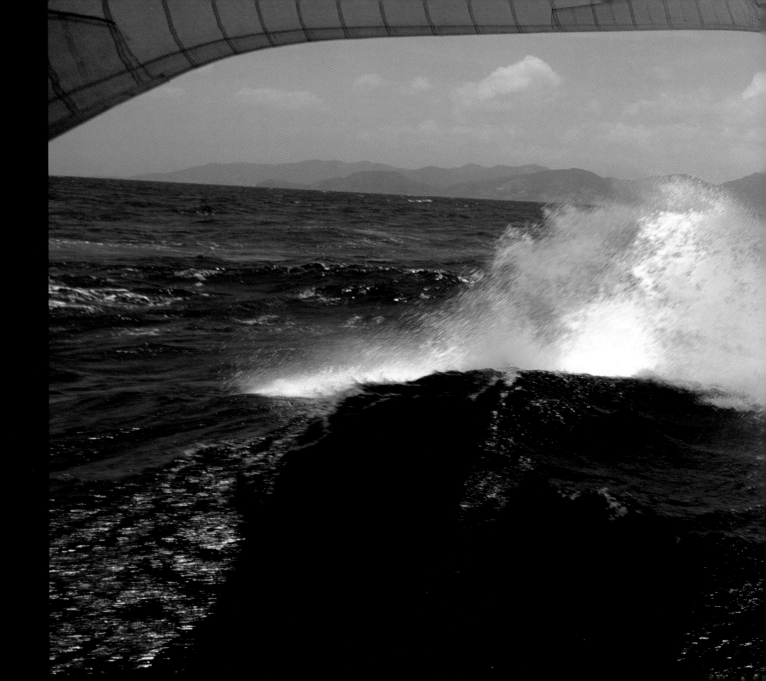

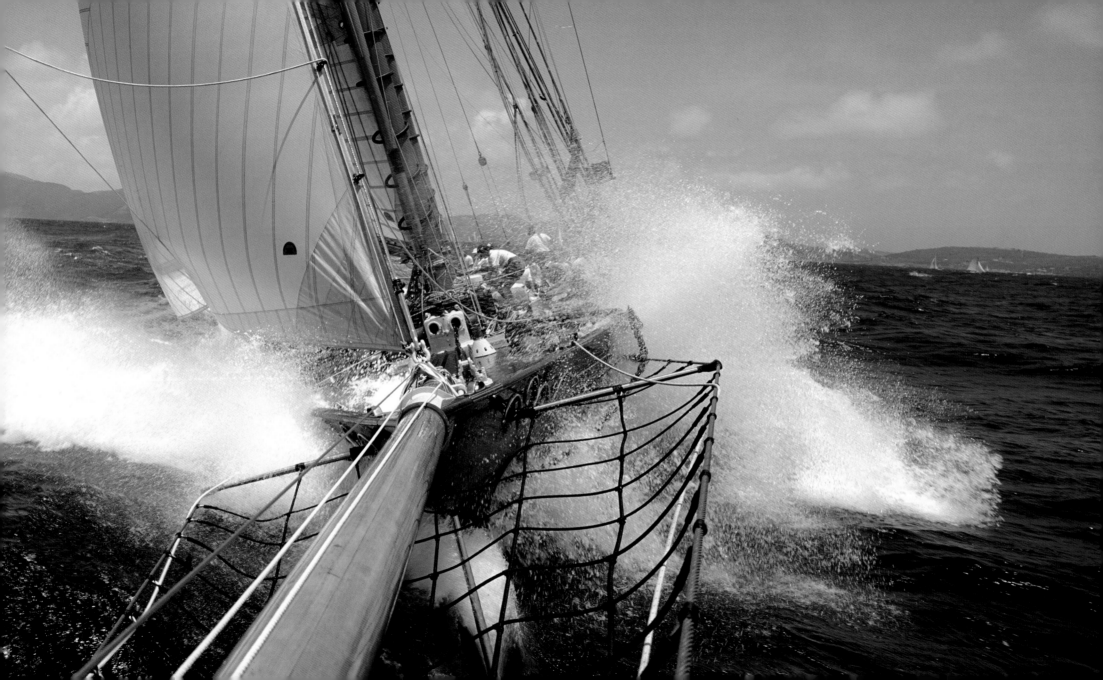

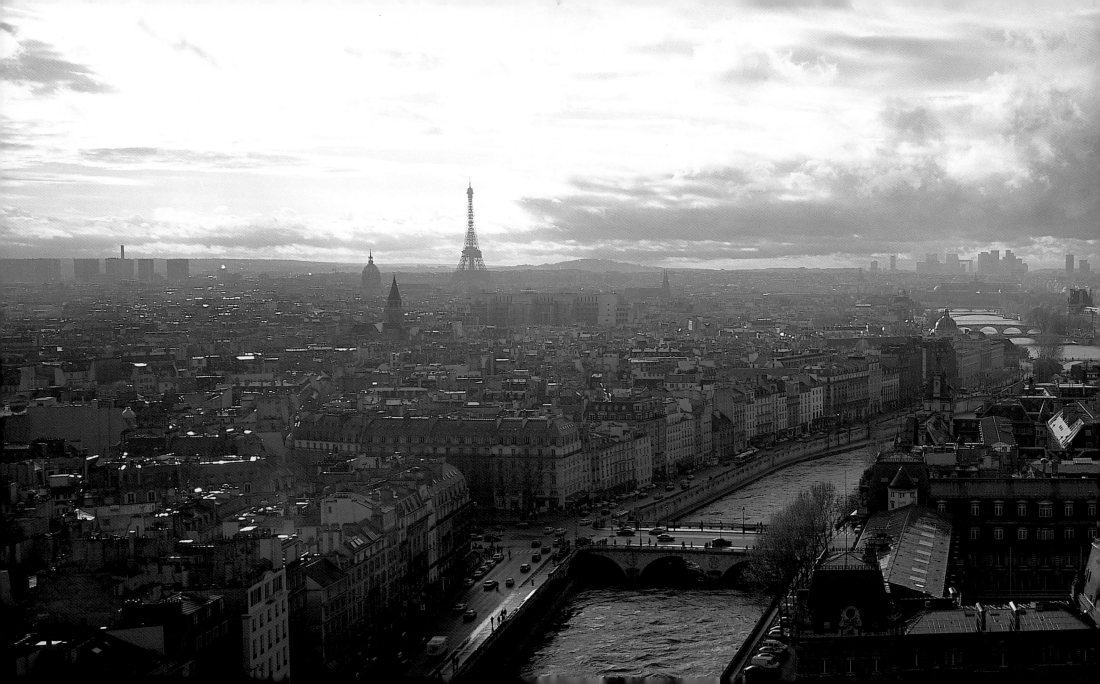

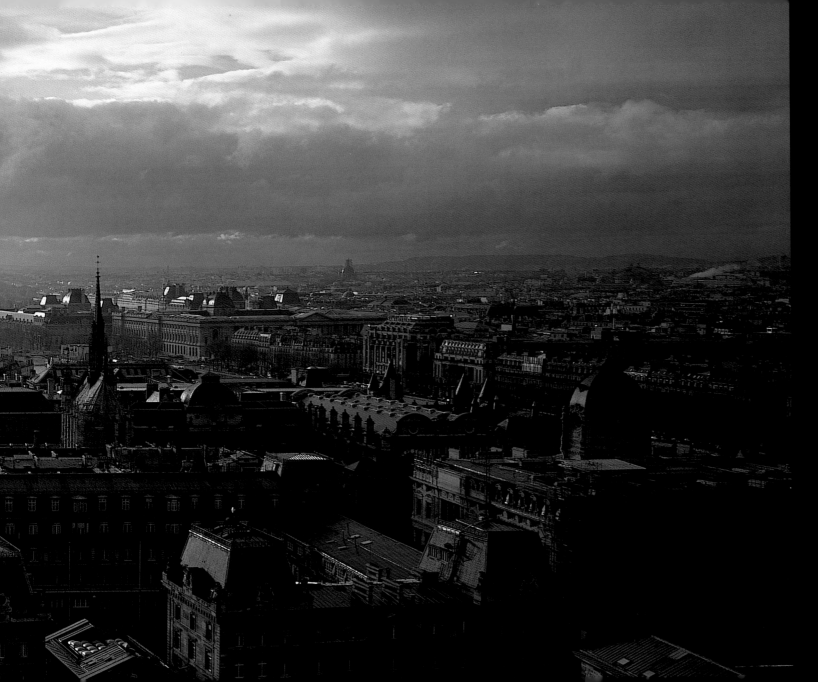

Nick Meers 19
View from the top of Notre Dame Cathedral, Paris, France
Hasselblad X-Pan
© Nick Meers

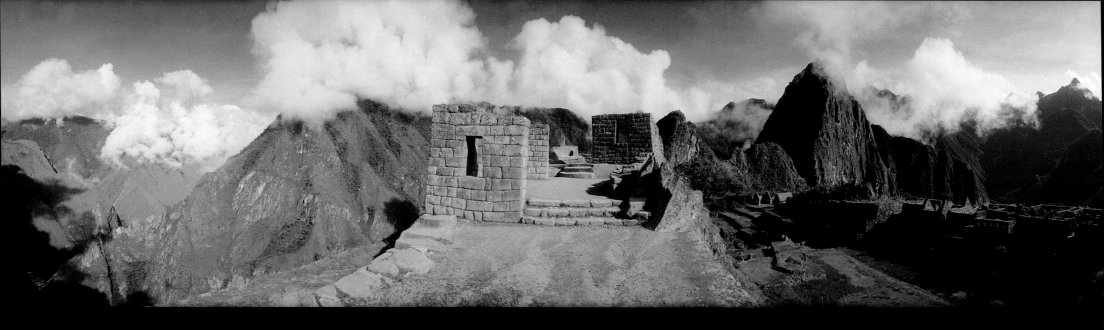

20 Everen Brown

Machu Picchu, Peru

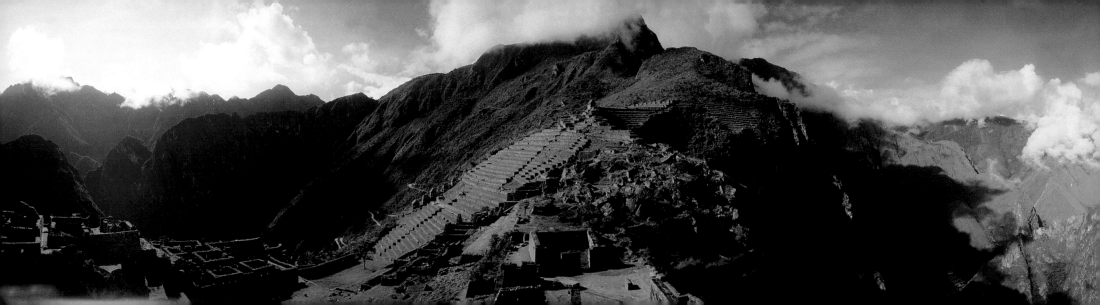

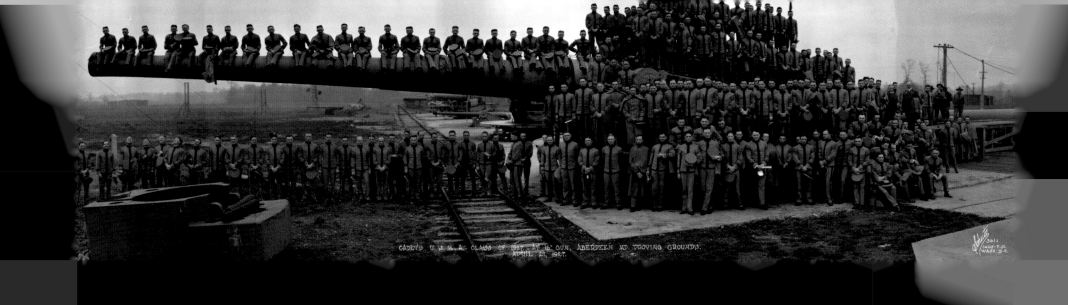

CADETS U.S.M.A. CLASS OF 1927 AT 16" GUN, ABERDEEN MD. PROVING GROUNDS.
APRIL 27, 1927.

what is panoramic photography?

a wider view

There must be people who remember, from many years ago, the occasional visits at school of a man equipped with a huge camera, who would eventually disappear under a dark cloth. There would be lines of children neatly standing on steps, forming a perfect arc so that the camera could spin around and capture everyone. And one child would find it fun to scamper around the back of the group while the camera rotated, so that they would magically appear at both ends of the finished photograph.

I was one of those children. Early on, I wondered about the mysteries of this arrangement that we know as the noble art of photography. I say noble, because to me there are very few occupations that rely on a sound knowledge and understanding of time and light in order to bring success. I consider it an honour to have been able to earn my living for more than twenty years using these vital elements of life. The magic of photography is one that has captivated generations of people. Fascinated with the potential to capture reality in all its shapes and forms, many ingenious experiments have brought intriguing visions to millions of people around the world.

The dictionary tells us that a panorama is a large pictorial representation that encircles the spectator; an unobstructed or complete view of a landscape or area; a comprehensive presentation of a series of events; or a picture exhibited a part at a time by being enrolled before the spectator. This last would seem to be an exact description of how 360-degree panoramas are viewed nowadays on computer screens: the viewer is invited to scroll in all directions as though viewing a vast scene through a keyhole, trapped in the centre of a visual sphere. This is a twenty-first century interpretation of what used to be called a Diorama, a representation of a three-dimensional scene, containing miniature figures and scenes set within a giant curved painted background – a convincing trompe-l'oeil. Dioramas, in one form or another, have been popular for centuries, and panoramic depictions of historical events have been found in many cultures. The Bayeux Tapestry was woven in the eleventh century, and, over the length of sixty-eight metres, tells the story of the Norman invasion of England. Panoramas captured with cameras are only the latest form of this special wider-than-normal vision.

Panorama comes from the Greek and fittingly stands for "all-seeing"; "pan" meaning "all" and "horama" meaning "sight". Panoramas are generally perceived as being distant views, stretched out and displayed in all their glory. These, however, are only what I would refer to as the "easy version" of this art. In fact, there are many more interpretations of this format, combining both the style and the "letterbox" shape of images. Panoramic images can be described as "an elongated space delineated by light and time", and may be made in a variety of ways, not all of them shot in one go, as one image. The invention of digital chips, with their potential for joining huge amounts of visual data seamlessly, has added a completely new dimension to our world, creating hitherto unseen images. Nowadays, some people refer to these digital linear images as "extended imagery" rather than panoramas, and we shall explore a variety of these in this book.

a brief history

The world's first commercially available photographic process, the daguerreotype, was unveiled to the world in 1839, and it didn't take long for a growing legion of practitioners in this new medium to realise that it was possible to shoot wider scenes than conventional cameras would allow. The earliest panoramic images were made by placing two or more of the distinctive silver-coated copper plates side by side, and it was not uncommon for photographers to place up to a dozen printed images together at a time, making spectacular panoramas covering very wide views.

Back then, panoramic photography was not as easy as it is today. The pictures had to be created in a conventional camera on wet plates, which first had to be coated with an emulsion and sensitised. For each exposure, the camera had to be rotated to the next section of the panorama and a new negative made. The wet plates then had to be developed in a mobile darkroom – often a tent or a light-tight box – on location, while the plates were still wet! Upon returning to the studio, the photographer would make a print from each negative by placing a sensitised sheet of photographic paper on the emulsion side of the negative in a contact printing frame. This frame was placed in the sun until the prints achieved the desired density. They were then fixed, washed, dried, cropped, arranged and mounted to form a panoramic photograph. It is also worth noting that, in the early days, it was simply not practical to develop huge wet plates in small rooms, and records exist of the laborious coating and developing processes taking place outside, at night, under a moonless sky.

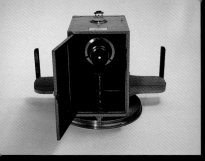

Johnson's "Pantascopic" camera, 1862.
Made by Johnson and Harrison, this camera was rotated by
a clockwork motor, which moved a flat glass plate past a slot
in the camera back at the same time to make the exposure.
© Science Museum/Science & Society Picture Library

Sutton "Panoramic" camera, c1861.
Made by Thomas Ross, this revolutionary design incorporated
a water-filled spherical lens developed by Thomas Sutton,
which enabled panoramic images of non-static subjects for the
first time. Only six of these cameras were ever made.
© Science Museum/Science & Society Picture Library

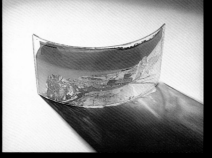

Curved panoramic negative, 1859.
This 10"x5"curved glass wet-collodion negative is one of the
few surviving examples produced by a Sutton panoramic
camera. The exquisitely-made wooden curved plate holder
and sensitising bath can be seen with the camera above left.
© Science Museum/Science & Society Picture Library

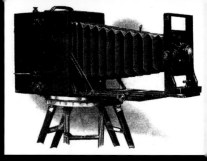

The Cirkut no.10, ManualsRus.com
This camera produced negatives 10" wide upon which the
fortunes of many group portrait photographers were founded

It was usually very easy to see the join on panoramic "joiners", as the technology was quite primitive back then. Some of the earliest panoramas were made by George Barnard in the 1860s for the Union Army during the American Civil War. His overviews of fortifications and landscapes were valued by engineers and generals alike, because of the useful information they contained. The Panoramic Photography Collection in the American Library of Congress (Prints and Photographs Division) contains approximately four thousand images featuring American cityscapes, landscapes and group portraits. These panoramas, which average between twenty-eight inches and six feet in length, offer a comprehensive overview of the nation, its enterprises and its interests, with a focus on the start of the twentieth century, when the panoramic format was at the height of its popularity. It seems there was no end to the many subjects covered by the nation's inventive minds. Patents were filed almost from the start for all sorts of fantastic inventions. The first recorded patent on a panoramic camera was in 1843, in Austria. The camera was hand-cranked, covered a 150-degree arc with an eight-inch focal length lens and used massive daguerreotype plates of up to twenty-four inches long. The more widely known Megaskop camera followed in 1844 and featured a novel swing lens operated by a handle and gears. It was invented by Friedrich von Martens, a German living in Paris. The first model used 4.7"x15" curved daguerreotype plates that also had a 150-degree arc. A later model used wet-plate curved glass emulsions.

There were other notable inventions along the way. The invention of flexible film in 1888 by Hannibal Goodwin was surely the turning point for panoramic photographers. Marketed by Eastman Kodak, it spawned a whole new generation of innovative cameras, including the legendary Cirkut.

Another notable advance came with the work of the industrious George Lawrence of Chicago, who in 1902 built cameras in seven sizes, some of which were swinglens panoramics, varying from 10"x24" right up to 26"x96"! In 1906, he made the world-famous panoramas of the San Francisco earthquake, some even shot with his cameras suspended from a series of kites. A truly marvellous feat of daring engineering, which produced stunning photographs too. Lawrence perhaps epitomises the pioneering spirit of a certain breed of panoramic photographer, who, faced with a lack of available equipment, found ingenious ways of getting around visual problems.

In 1904, the Rochester Panoramic Camera Co. took over from its inventors the manufacturing of the famous Cirkut No.10 and No.16 cameras. The No.10 could take up to 360-degree views on a fan-governed clockwork mechanism, using ten-inch-wide roll film. This became the panoramic camera most widely used by professional photographers. There are still a few around today, though sadly most are owned by collectors who do not use them.

The floodgates were opened, and photographers could not shoot enough panoramas. All sorts of weird and wonderful new cameras appeared with variations on the rotating theme. The angles of view got wider, as did the variety of the cameras' names: the Cylindrographe, the Cyclograph, the Cycloramic, the Wonder Panoramic, the Pantascopic, the Multiscope, the Cyclorama, the Panorax, the Veriwide, the Viscawide, the Ultrawide, the Cyclo-pan, the Technorama, the I-Pan, the Hulcherama, the Globuscope, the Panoscope, the Electropan, the Widelux, the Roundshot, the Cyclops Wide-eye, the Lookaround, the Pinoramic, the V-Pan, the X-Pan, and even my own Z-Pan, to name but a few.

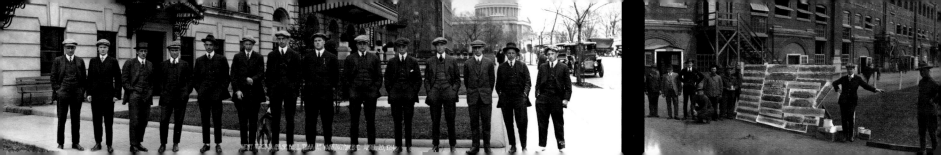

WEST VIRGINIA BASE BALL TEAM AT WASHINGTON, D.C. APRIL 20, 1916

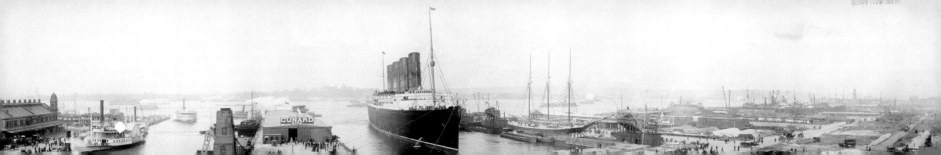

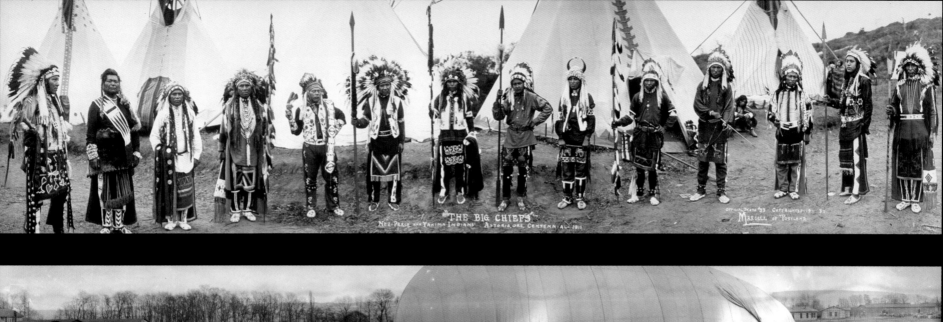

TOP

"The Big Chiefs" of the Nez-Percé and Yakima Indian tribes meet at Astoria, Oregon, USA, 1911

US Library of Congress, Prints and Photographs Division

6a25392

BOTTOM

Fred Schutz

The 1st balloon company at Ehrenbreistein Fortress on the Rhine, Germany, 1919.

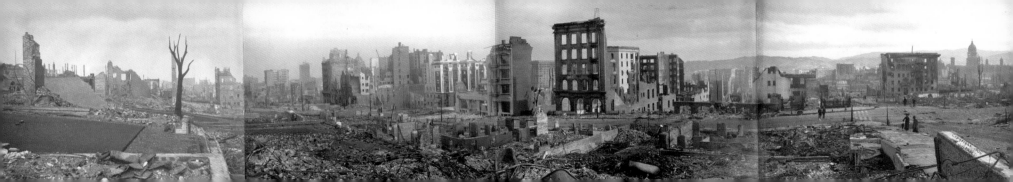

panoramic masters: david noton

It took David Noton a while before starting his business as a panoramic photographer. He spent some time as a deck officer in the Merchant Navy, developing a taste for travel while sunning himself abroad. Several years, and jobs, later, he decided it was time to go back to college to study photography. Landscapes had always been his first love and so he learnt to shoot landscape and travel photographs. David decided to try out the panoramic format about twelve years ago and so rented a Fuji 617. He took it to Venice for a week and became hooked. He couldn't get the panoramic format out of his system and, a little later, rented a swinglens 120 Widelux camera. However, he wasn't very impressed with it because of the camera's limited shutter speeds and the difficulty of effective filtration. He then once again rented a Fuji 617 to shoot some coastal work, and some time later bought his own.

On being asked if he has any particular preferences for format types, he replies immediately that it's the 6x17cm, "no contest with anything else". He's very happy with the convenience of medium format, and now owns a Fuji GX617 with two lenses, the 90mm and the 180mm. He appreciates their great optics, their ease of transport (the cameras are relatively rugged and transportable), and fairly simple construction – a great advantage when travelling through deserts and rainforests.

David's preferred subject is nature, in all its variety – not only the raw and untouched, but also where man has left his imprint. As he dislikes working in winter weather, with short daylight hours, he tries to go shooting in the southern hemisphere during England's wintertime. When composing a panoramic image, he previsualises the picture to fit the lenses available before setting up the camera, while still remaining open to later alteration. In the main, he knows the image he wants to make long before he gets the camera out of its case. Fine-tuning is usually down to the placement of trees or other foreground objects that might affect the final composition. He always shoots transparency film, and occasionally black and white negative film. David uses the spot-metering method, which can sometimes cause problems across a wide area. He tries to work out what the key part of the subject is, and meters accordingly.

On the subject of filtration, David's most basic tool is the Neutral Density graduated filter, an essential for balancing up the differential in light. He occasionally uses warm-up filters, and inverting graduated warm-up filters are a good effect for cool foregrounds. He sometimes also uses ND filters to slow the exposure and accentuate water movement. He doesn't use any extra lighting.

A big problem with fixed-lens cameras is the "keystoning" effect that appears at the corners of wide-angle pictures when the film plane is moved away from the vertical position: buildings appear to lean inwards, and upright lines become distorted at the edges. On a large-format monorail or field camera, it is simple to add a slight upward shift to the lens to retain the verticals in a straight line across the picture plane. With a flatback panoramic camera, one has to try to avoid this by keeping it level, sometimes using a spirit level on the camera. David says that cityscapes give him the most problems in this regard, and therefore takes more care about levelling off the camera when setting up.

David's idea of a dream panoramic camera would be a 6x17cm format, capable of accepting a wide range of focal length lenses from 20 to 800mm, with shift movements. It should also be very light, "about twenty grams". He would be interested in shooting an even wider format, and has thought about pursuing the world of 360-degree photography. Very few that he has seen are visually effective, so he's always been intrigued to test the possibilities.

One of the most constantly challenging things about travel photography is the hanging around, waiting for the right lighting situation, especially in a location that is exotic (and expensive to reach). David once waited a full two weeks for a shot of the famous landscape around Guilin in China. Waiting is obviously a normal part of the work, but there are many psychological battles involved in being ready for light that is special enough to shoot!

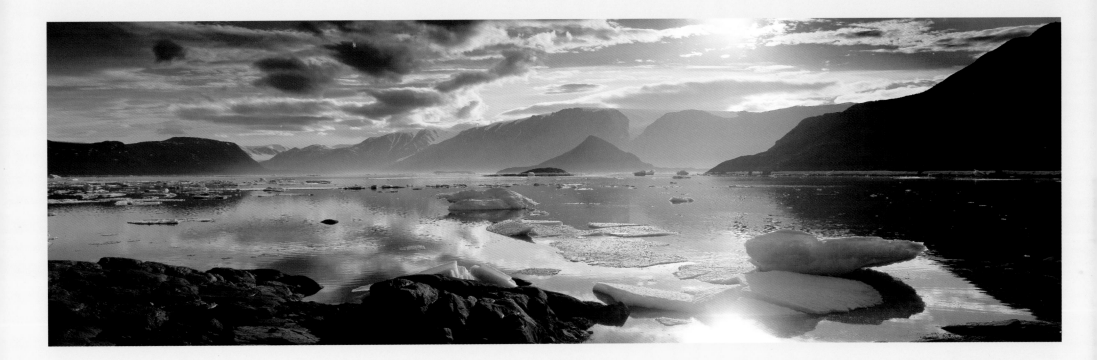

"This was shot on a kayaking expedition in the Canadian Arctic. At times, the water in between the pack ice would be like glass, with perfect reflections and sparkling light for twenty-four hours a day. At other times, with low grey clouds and the wind coming off the ice cap, it was distinctly hostile. We'd paddled down this fjord and set up camp on this island. As the clouds parted, we were presented with this spectacle, a shot which means much to me as it represents such an epic adventure. It was so pristine and remote – the only sounds were the walrus barks echoing around the fjord. Carrying all our camping kit, food, water and photographic gear for two weeks in the canoes was a challenge."

Alexandra Fjord, Ellesmere Island, Canada
Fuji G617 with 105mm lens
© David Noton

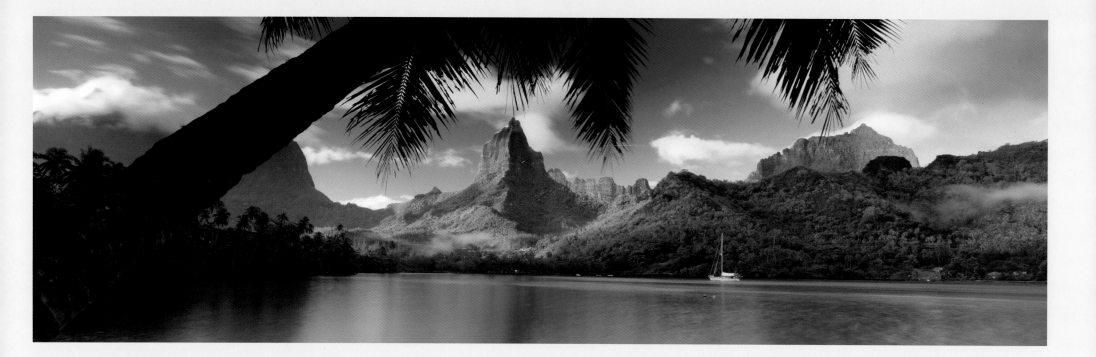

32

"Ever since seeing the film The Bounty I've wanted to visit Tahiti. I've been lucky enough to have visited many of the world's most beautiful tropical islands, but I'd have to say this is my favourite. The peaks in the centre of the island attract a lot of rainfall and are often shrouded in localised cloud. The location search for this picture was quite protracted, I knew what I wanted, but finding the right overhanging palm involved lots of hacking through undergrowth and wading. After that, it was just a case of waiting – though obviously there are worse places to be hanging out. After about a week on the island, the combination of overnight rainfall clearing just in time for the first light of day gave me the clarity of light and traces of mist still clinging to the peaks I'd been waiting for. Working in the tropics is always a hasty affair; the light comes up so quickly. It was all over in a few minutes. I then spent the next few weeks wondering if it had worked."

Oponohu Bay, Moorea, Tahiti
Fuji G617 with 105mm lens
© David Noton

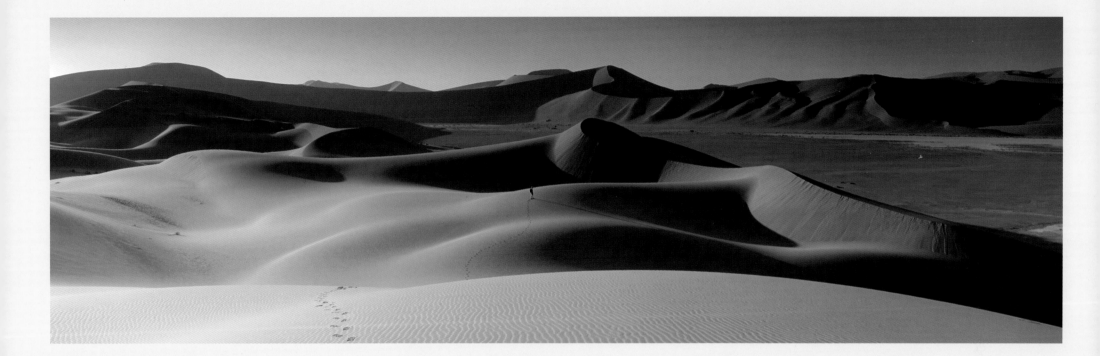

"We'd been working here for several days in consistently great light, normally an unheard-of luxury. As it's a National Park, we were camping some sixty kilometres away and driving in at 4am every morning for the dawn light. The days were spent trying to shelter from the heat just waiting for the evening light. This location had been found the day before and I knew it had great potential. I shot several versions whilst my wife waited patiently. I thought I'd finished, but as Wendy walked into the frame, it became immediately apparent the shot was far stronger with her present in the image to give it scale. As the desert is constantly shifting and changing, I like the idea that this image can never be repeated.

Trekker on the Sand Dunes
Namib Desert, Namibia
Fuji G617 with 105mm lens, Fuji Velvia
film + 0.9ND graduated filter
© David Noton

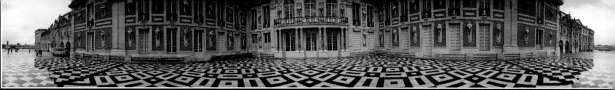

1

2

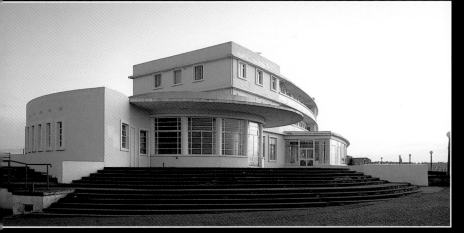

3

4

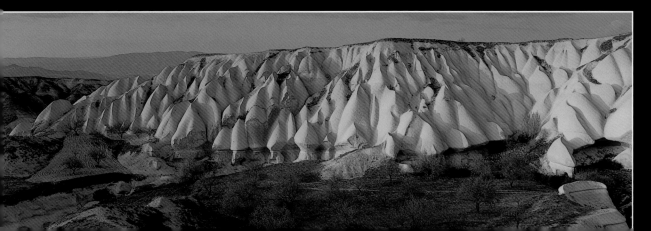

1. Bench on the seafront, Hastings, UK, 1999
Nikon FE camera
The standard 35mm film frame is 24x36mm, with a length to height ratio of 3:2. This film format is considered "normal" for many photographers, but is not capable of massive enlargement without showing its grain structure.
© Trudie Ballantyne

2. The walled town of Obidos, Portugal, 2001
Hasselblad X-Pan camera
The dual-format Hasselblad is unique in being able to shoot both standard 24x36mm and panoramic 24x65mm frames on the same roll of 35mm film. This new format's ratio is 2.7:1.
© Nick Meers

3. The front door at the Palace of Versailles, France, 1999
Globuscope camera
The Globuscope also uses 35mm film and the length used depends on the angle of view required: a full 360° view will use 158mm length of film.
© Everen T. Brown

4. Midland Grand Hotel, Morecambe, UK, 1998
6x12cm rollfilm back on Linhof Technika 5"x4" camera
The 6x12cm format is the shortest of the panoramic rollfilm formats, with a ratio of 2:1, it is exactly twice as long as it is high. This ratio can also work very well as a vertical orientation.
© Nick Meers

5. Wind erosion in Cappadocia, Turkey, 1993
Fuji G617 camera
This format is much-loved by panoramicists, being almost a 3:1 ratio. It produces four exposures on a standard 120 roll of film.
© Nick Meers

panoramic cameras

Three types of camera, three ways to shoot

Panoramic cameras are built with one thing in mind: to gain a longer-than-normal aspect ratio. Their entire construction, sometimes elongated, sometimes short and dumpy, is specifically designed around trying to get enormous amounts of light onto an elongated strip of film. The very least one can expect from a panoramic camera is a ratio of 2:1. This means that the length of the picture will be exactly twice its height. Compare that with a standard 35mm SLR camera's 3:1 aspect ratio, and you can see an elongation occurring. When very long 360 degree-and-beyond images are shot, or digitally stitched together, the aspect ratios can become extremely elongated, thus creating their own problem, i.e., how to be displayed for maximum effect.

The most popular example of the 2:1 aspect ratio is the 6x12cm format, producing six frames/negatives on a standard roll of 120 film. Horseman, Silvestri, Linhof and Noblex, the main contenders, all make cameras in this format, though only the Noblex is a swinglens example among the flatbacks. Aspect ratios continue from there to the more normally-accepted 6x17cm panoramic format, an aspect ratio of nearly 3:1, and upwards through 6x24cm (4:1) to the infinity of ultra-wide formats, some of which are extremely long. Aspect ratios are a very important consideration, as they affect not only the final outcome of a panoramic photograph, but also the whole means of capturing the light on film to create a panorama, hence the sometimes strange construction of the cameras.

Equally as important as the format is the style in which one can shoot it. Panoramic cameras fall into three distinct categories, and each one captures light and controls perspective in entirely different ways. It is important to understand the differences between them, as their characteristics affect the way that panoramas are made, and the way the finished photographs will look.

There are three main categories of panoramic camera, generally described as flat- or straightback cameras, swinglens or short-rotation cameras, and full-rotation or slit-scan cameras, which are sometimes capable of doing more than a mere 360 degrees (dependent on film supply).

Because of the principles involved, panoramic cameras can be ingeniously simple devices; all seem outlandish, some are fiendishly clever and most are outrageously expensive.

1

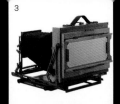
2

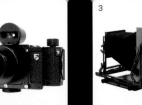
3

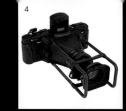
4

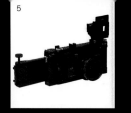
5

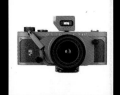
6

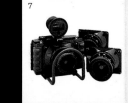
7

8

Flatback cameras

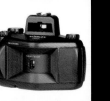
1

2

3

4

5

6

Swinglens cameras

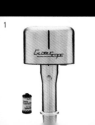
1

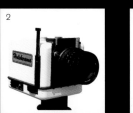
2

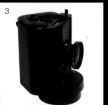
3

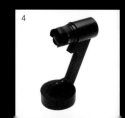
4

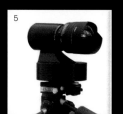
5

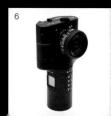
6

7

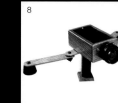
8

Flatback cameras

1. Hasselblad X-Pan: Dual-format rangefinder camera offering the advantages of 35mm, plus the option to switch from the 'normal' 24x36mm shape to the panoramic 24x65mm in mid-film. Available 90mm, 45mm and 30mm lenses. Made in Japan/Sweden.

2. Tomiyama Art Panorama: A super-wide camera designed for use with wide-angle lenses on 6x17cm or 6x24cm formats. It has an interchangeable lens board with built-in adjustments, an optical viewfinder and built-in focusing screen. Made in Japan.

3. Canham 4"x10": A modular design handmade wood and metal field camera with special panoramic darkslides. The camera can also be converted into either a 5"x7" or a 4"x5" by interchanging the entire rear standard/bellows/back assembly. Made in USA.

4. Fuji GX617: Uses 120 or 220 film for a 6x17cm format. Four interchangeable lenses available: 90mm, 105mm, 180mm and 300mm. Each lens comes with a dedicated precision viewfinder for precise framing. Optional focusing screen. Made in Japan.

5. Gilde 66-17 MST: This multi-format camera features shifts and tilts, vario-viewfinder, removable film back with integral ground-glass screen, and the ability to shoot five different formats which can be changed mid-roll if needed: 6x6, 6x9, 6x12, 6x14 and 6x17cms formats. It will work with focal lengths from 47mm to 720mm, and features many extra possibilities. Made in Germany.

6. Linhof Technorama 617: Linhof invented the 6x17cm format in 1976, and developed the 612 Technorama later. The 617 uses 120/220 film, and has four interchangeable lenses: (72mm, 90mm, 180mm, 250mm) with integrated helical focusing and dedicated viewfinders. In addition to the standard black body, it is now also available in 5 different colours. Made in Germany.

7. Horseman SW612 PRO: This hand-holdable super wide-angle 6x12cm has shift capabilities in both directions and interchangeable film holders and lenses. It can use 6x7, 6x9 and 6x12cm rollfilm backs, with lenses from 135mm to the ultrawide 35mm. Made in Japan.

8. Z-Pan: Designed by the author and built by Gandolfi, this combines a 6x17cm panoramic film back (from a Fuji G617) with a Linhof TechniKardan monorail camera, allowing the use of lenses from 72mm to 800mm, with view camera swings, tilts and shifts.

Swinglens cameras

1. Noblex 135U: This camera sees a 136° angle of view through a 1.4mm fixed slit, and makes 19 24x66mm images on a standard roll of 35mm film. Filters may be attached magnetically. The rotating lens drum, driven by a high-powered DC motor, makes one rotation per exposure. Exposure speeds are created by variation in the drum speed. Equipped with a 29mm fixed focus lens, it may be used with the optional Panolux 135 exposure regulator module. Made in Germany.

2. Noblex Pro 6/150: With a picture angle of 146°, this camera makes six 50x120mm exposures on a standard 120 roll film through a 3mm fixed slit. Filters may be attached magnetically. The rotating lens drum, driven by a high-powered DC motor, makes one rotation per exposure. Exposure speeds are created by variation in the drum speed. Equipped with a 50mm fixed focus lens, it may be used with the optional Panolux 150 exposure regulator module. Some models have shift capability. Made in Germany.

3. Widelux F8: The first Widelux camera appeared in 1948. The 35mm F8 offers a 140° view and weighs only 30 ounces. It creates 24x59mm images from a fixed-focus lens, is completely mechanical, has a built-in spirit level and a full-frame viewfinder. The 120 version, named 1500, covers a 150° angle of view and weighs 62 ounces. Made in Japan.

4. Horizon 35mm: This 35mm curved film plane, mechanical camera has a metal chassis covered by a plastic body. The swing lens design covers 120° horizontally and 45° vertically, with a built-in level visible from the top or in the viewfinder. It comes with a 28mm lens and creates a negative size of 24x58mm. Made in Russia.

5. Widepan 120 Pro: Introduced at PhotoKina 2000, this mechanical swing-lens, curved film plane camera is not often seen in the west. It shoots 55x110mm exposures on 120 rollfilm through a 50mm lens. There's an optional 35mm film adaptor. Made in China.

6. Mottweiler 'Pinoramic': This handmade camera was invented in 1991 as a simple daylight-loading, pinhole panoramic camera. It produces a 6x12cm image on 120 rollfilm, covering a 120° field of view. An f/200 pinhole is positioned at a uniform 60mm from the curved film plane, which produces even illumination across the image. The shutter is pneumatically controlled. Made in USA.

Rotational cameras

1. Globuscope: This 360° mechanical camera weighs 3.5lb, sees a 51° vertical field with its 25mm lens, and makes eight exposures of up to 158mm long on a 36 exposure roll of 35mm film. It is spring-driven, runs silently, and requires no batteries. Made in USA.

2. Hulcherama 120s: This 360° battery-driven camera weighs about 5lbs. It uses lenses from either the Hasselblad, Pentax or Mamiya 645, and is equipped with adjustable slit "shutter", variable speeds and adjustable lens shift. The through-the-lens viewfinder enables accurate composition, and it creates images 6x23cms long on 120 rollfilm. Made in USA.

3. Mottweiler Fosterpan: A large format 360° camera designed for backpacking, the 5lbs 9oz battery powered Fosterpan produces a 5x22¼" negative from its 90mm Super Angulon lens. Controls include a computer interface, slit selection knob, rise and fall knob, a 15-stop shutter speed range and variable angles of view. Made in USA.

4. Spheron Panocam 12FX: This high-resolution digital camera has a maximum resolution of 5200 vertical pixels, weighs 1.8lbs, and can produce spherical panoramic images of up to 100Mb in size with no stitching. A smooth DC motor rotates the camera around a vertical axis, making it ideal for QuickTime VR work, interiors and car photography. Made in Germany.

5. Spheron PanoCam 12X: Similar to the 12FX, this battery-driven high-resolution 360° digital camera is operated via a notebook computer. Its variable scan speeds make it capable of producing panoramic images of up to 100Mb. Made in Germany.

6. Seitz Roundshot 28/220: This 360° battery-driven camera delivers three images on 120 rollfilm, or six on 220 film, using any 28mm lens from Nikon, Contax or Leica-R cameras. The resulting 50x80mm images have a picture ratio of 3.6:1, making it the widest medium-format panorama available. Made in Switzerland.

7. Seitz Roundshot SuperDigital 2: A 360° battery-driven high-resolution digital panoramic camera, with a maximum resolution of 2700 vertical pixels. Accepts Nikon, Leica or Contax SLR lenses, creating (for example) a 90Mb file size with Nikon 14mm lens, and a 178Mb file with Nikon 28mm lens. Made in Switzerland.

8. Lookaround: This handmade mechanical rotating camera is made to order in oak, cherry, walnut or mahogany. It uses standard 35mm film, has a standard lens mount that will take 24mm to 35mm SLR lenses, and a changeable exposure slit. Because it has no batteries or gears, it runs smooth and silent, powered by a spinning flywheel. The lens board may be shifted, and the camera is light and well-balanced for hand-holding off-axis, making it simple to shoot 3 or 4 continuous 360° revolutions on one strip of film! Made in USA.

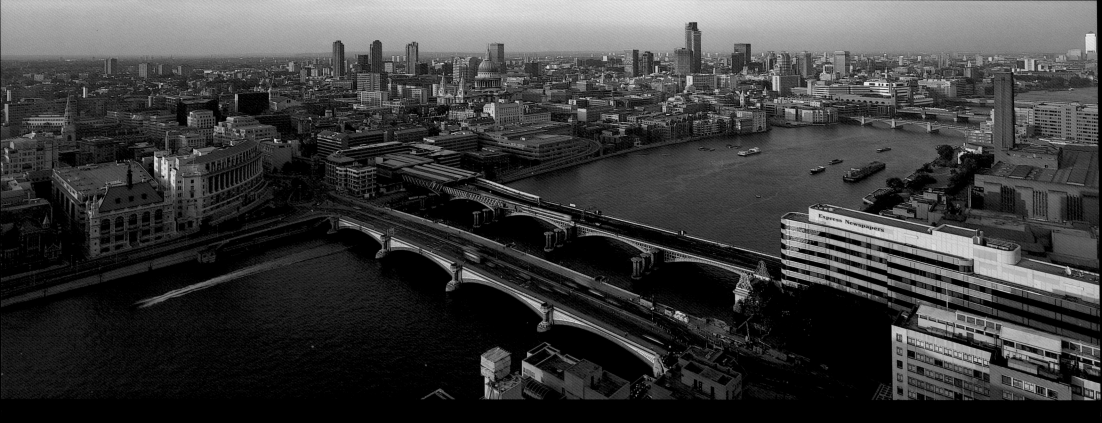

38 Looking east across Blackfriars Bridge towards the city of Nick Meers
 London. Note how the vertical lines of the buildings remain River Thames, London, UK
 upright due to a "dropped" front lensboard, essential when Z-Pan 6x17 camera,
 shooting from such a great height to avoid a "keystoning" effect. 72mm lens, centre-spot filter
 © Nick Meers

Flatback cameras

Flatback, or straightback, cameras are typified by the 35mm Hasselblad X-Pan, the 6x12cm Horseman Superwide, the Fuji GX617, the 6x12cm and 6x17cm Linhof Technoramas, and field cameras with film backs covering 6x12cm, 6x17cm, 4"x10", 5x24cm, even 6x36cm. These all have varying degrees of lenses projecting light onto a flat film plane, using mainly wide-angle, and in some cases, telephoto, lenses. The optical effect of these cameras is similar to slicing a straight section through the centre of a larger film format, hence the simple cropping action performed by smaller APS and 35mm point-and-shoot cameras that make you think they're turning panoramic: they are simply cropping a larger area into a "letterbox" shape.

While maintaining a flat-film plane, the aspect ratio of these cameras changes with the length of film they each hold. Thus, the dual-format X-Pan produces both a normal 24x36mm and a panoramic 24x65mm image (almost 3:1 ratio); the Horseman produces a 6x12cm format (2:1 ratio) and the Fuji a 6x17cm (almost 3:1 ratio); the Linhof comes in both 6x12cm and 6x17cm, and the Art Panorama produces 6x17cm and 6x24cm (1:4 ratio) formats. It is even possible to change lenses on some of these cameras, increasing their versatility on location. A recent newcomer is the Gilde 66-17MST camera, an extraordinary multiformat flatback camera that shoots five formats from 6x6 through to 6x9, 6x12, 6x14 and 6x17cm, any or all of which can be selected while shooting a 120 or 220 roll of film! It even has shift and tilt facilities.

Flatback cameras are ideal if you need to shoot architectural pictures, across parallel lines, or any subject where you need plenty of undistorted information across a wide area. Straightback cameras also offer the important advantage of being easier to synchronise with flash lighting, as they are controlled by a single, one-point shutter. They do sometimes, however, need the addition of a centre-spot filter to even out the light falling on the film plane (see chapter on accessories).

Here, the camera has been used on its side. To retain the vertical lines, the front lensboard has been moved sideways to achieve the equivalent of an upward shift.

Nick Meers
Construction site at Canary Wharf, London, UK
Z-Pan 6x17 camera,
90mm lens
© Nick Meers

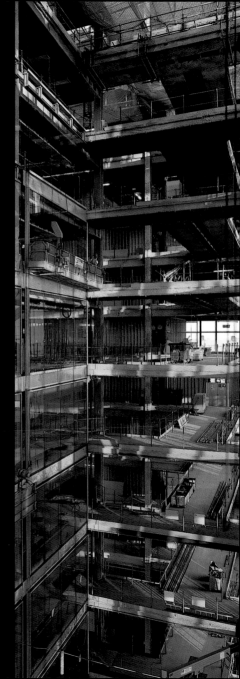

Swinglens cameras

Swinglens, or short-rotation, cameras, are constructed in such a way as to enable a thin strip of light to scan across a curved film plane. The very early panoramic cameras were made using this principle, and it is usually this type of camera that people first encounter in group school photographs, where somebody traditionally scampers around the back of the group to appear at both ends of the picture, while the camera slowly cranks around. There are still a few old Cirkut cameras in use today, capable of shooting a full 360 degrees, but these are often used for shorter runs. Indeed, their enthusiast groups like nothing better than discussing the gear ratios that drive the cameras at differing speeds.

The most commonly seen swinglens cameras are the Widelux and Noblex cameras, in both 35 and 120mm film formats. Noblex make both a 6x12 and a 6x17cm model. Because they scan from a point source across, typically, 140 degrees of view, they are most akin to human vision, and though difficult to use effectively, are often hailed as the only representatives of "true" perspective.

The mechanism involved in making these lenses swing smoothly is often their weakest mechanical trait, the Widelux being notorious for taking its time getting up to speed from one side of the exposure to the other. Noblex fixed this problem by designing a shutter that gets up to speed with a half rotation before it exposes any film to the light, a much more successful solution.

This was taken at the same location as the picture on page 39, but for this shot I used a swinglens camera as a comparison. The trademark curved effect is magnified here by so many "straight" lines making their own perspective.

Nick Meers
Construction site at Canary Wharf, London, UK
Noblex 175 6x17 camera
© Nick Meers

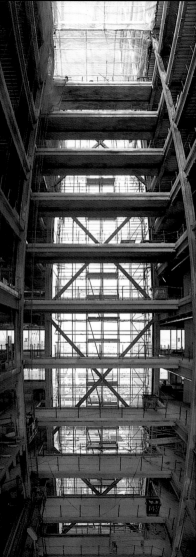

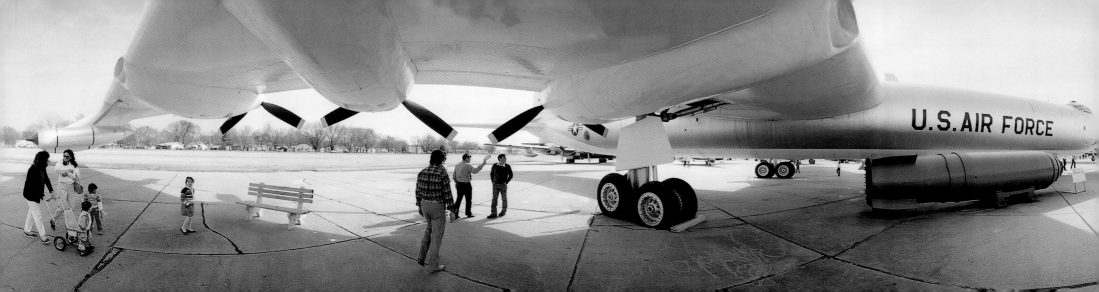

Rotation cameras

Rotation, or slit-scan, cameras, such as the Globuscope, Alpa Roto, Hulcherama, Roundshot, Cirkut and the digital Spheron PanoCam, are capable of making 360-degree, full-circle exposures. Some can even keep going for three or four full rotations, again according to the film available. They can also be programmed to shoot shorter rotations, such as 90, 140, 180 or 270 degree exposures, but must be set up extremely carefully. These cameras are used mainly in architectural and industrial photography as specialised recorders of specific items. There are a few photographers who persist in shooting landscapes, but their use is limited to very few suitable locations. One of the unique aspects of rotational cameras is that they produce a very different perspective to any other type of camera. Straight lines become strangely curved, and anything equidistant from the camera will appear as a straight line. Some call it distortion, others argue that these cameras reveal a "true" perspective.

Other notables in this category include the 35mm Spinshot and Lookaround cameras. The Lookaround, made from something similar to a cigar-box with extending counterbalanced 'wings', will shoot beyond 360 degrees dependent on the length of film within. They can easily be handheld, as can the Globuscope, not necessarily horizontally, enabling versatility hitherto unknown in panoramic photography, and produce some very interesting results.

This last full rotation category has recently become the domain of the digital specialists, such as the Spheron Panocam. With the right set-up, it is now relatively simple to shoot QuickTime Virtual Reality (or QTVR) pans that not only see 360 degrees in the horizontal plane, but can even cover an entire sphere of imagery above and below. QTVRs are ideally viewed on computers, where the viewer is invited to peer through a "window" at the image, and navigate around it by means of the keyboard arrow buttons. Travel and estate agents have quickly seen the potential of QTVR websites to advertise their holidays and properties, and it is now common to take "virtual tours" around many different places without ever having to leave the glare of the computer screen.

Of course, you don't have to spend a fortune on an all-singing, all-dancing, all-tea-making expensive machine to capture a vast digital file. One of the great advantages of working digitally on computers is that there are now some very efficient and inexpensive "stitching" programmes available on the internet, such as Photo Vista, Picture Publisher, PanaVue and Panorama Factory, which assemble images quickly and effortlessly from a folder of digital files, hiding the seams and blending the edges to form impressive panoramas. Choosing which panoramic camera to shoot with depends to a large degree on the desired outcome, and, as we shall see, the results can be dramatically different according to which type of camera you choose.

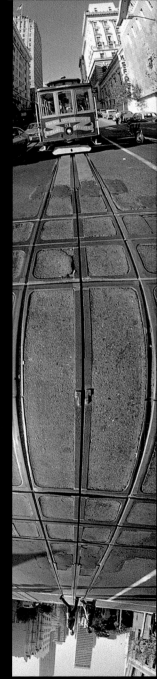

This 180-degree view was made with the camera on the end of a tripod, while spinning in the vertical axis.

Alan Zinn
Cable car, San Francisco, USA
Lookaround 360-degree camera
© Alan Zinn

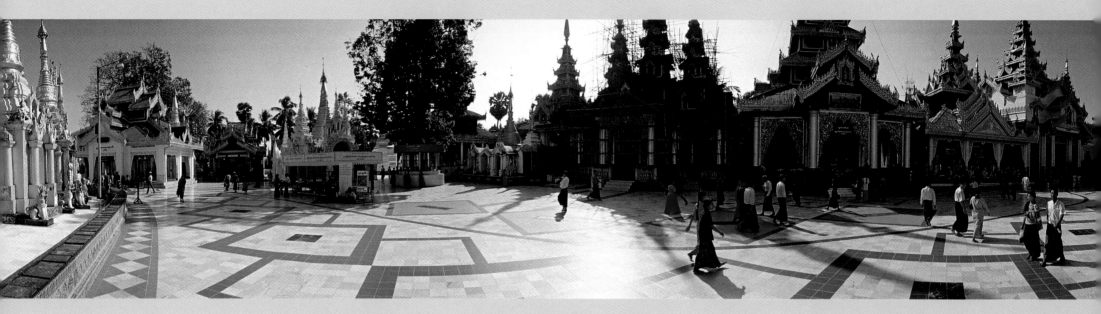

panoramic masters: everen brown

Everen T. Brown is the foremost user of the unique 360-degree Globuscope camera, a strange-looking machine that weighs just three pounds, can be handheld, is simple to transport in a backpack and will go anywhere as it needs no batteries. Everen spends more than one hundred days each year out on the road gathering images. He has travelled to more than one hundred countries in all the major continents including both Poles and has shot around 100,000 images – thus creating what he believes to be the world's largest collection of 360-degree virtual reality panoramas.

Everen's first attempts at image-making started early. He has fond memories of, as a six-year-old, partaking in his family's home movies. They used to make standard and super8 films, taking them seriously enough to construct story lines and costumes, even rehearsing them. He always had a

penchant for photography. In 1981, aged twenty-one, he saw a breathtaking double-page spread of pictures in the *Gentleman's Quarterly* magazine; they were panoramas of various American scenes, taken with the newly invented Globuscope camera, and he was instantly inspired to want his own. He saved and saved, and eventually bought one in 1986.

The camera interested him not only for its obviously unusual spinning talents, but also because of its fast operation. He feared that working with a "normal" camera on a tripod would slow his life down too much. He learned how to shoot on the fly, always wanting to portray a sense of "you are there" in his photography, without wishing to be too laborious in achieving it. His inaugural adventure with the camera was to the Andes in Peru, where he made his first set of pictures at Machu Picchu.

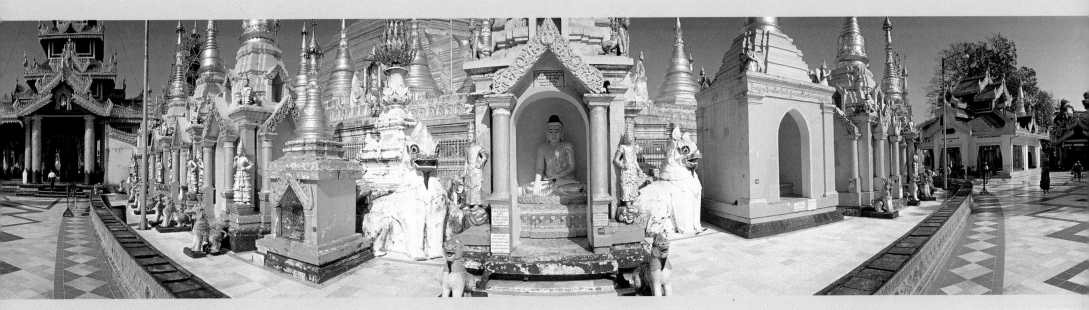

He was so pleased with the results that he still has a 10"x72" colour print on his office wall from that first trip, an image that he has subsequently sold many prints from. Although he also sometimes shoots video and 35mm snaps, it is for his panoramas that Everen is best known. He makes them primarily for his own satisfaction, concentrating on subjects that excite him. He feels that it is important for him to create a body of work he can be proud of, based on his various interests and whims. If he can later sell rights to those images, then that occurs almost as a happy consequence. His panoramas are mainly licensed for virtual reality usage in many online applications such as encyclopaedias – Microsoft's Encarta being just one of them. He accepts very few commissions, as he would rather shoot images on his own terms than to be "told what to do by a complete stranger".

Since the age of 15, he has wanted to go and see the world, absolutely certain in the back of his mind that "man would eventually completely ruin it all". He carries a strong conviction that he is shooting his panoramas almost as a historical document, for someone in the distant future that he'll never meet or know. Everen feels he is creating a visual time capsule of as much of the planet as he can, hoping that his vast library will one day enable people to travel back in time to see what the world that he lived in was once like.

Unfortunately, his vision is already occurring sooner than expected, as we can no longer see the views across New York from the top of the World Trade Center Twin Towers, since the terrorist attacks that destroyed them on September 11th, 2001. Everen had recorded a series of images to

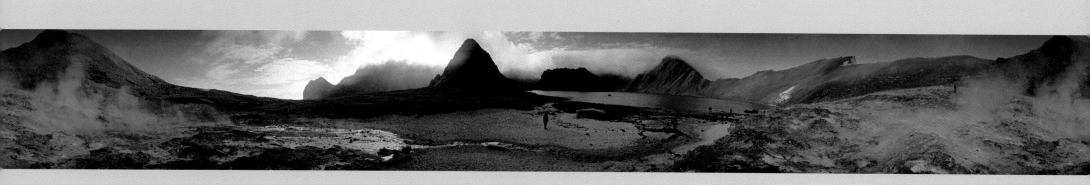

mark the dawn of the new millennium, on January 1st, 2001, blissfully unaware of what was to come. In the dreadful aftermath of the disaster, he reacted by printing 30,000 posters of the well-known view, and personally distributed half of them to the fire-fighters, police officers and other workers at "Ground Zero" for free. The remaining 15,000 posters were sold to raise money and the profits were donated to the American Red Cross and General Disaster Relief Fund, a project he found very emotional.

When Everen was travelling in Tibet, he captured the special moment we chose for the cover of this book: "A photographer is always at the mercy of the weather. After spending a few delightful days in Lhasa, Tibet, I was surprised by an overnight storm that blanketed the city with twelve inches of snow. I figured transportation would be very difficult and the day's shooting would be ruined. An early-morning trek to Drepung Monastery started disappointingly. Walking up the steps of the monastery, I soon found myself dodging snowballs from the rooftops and engaging in a little fun as well. When I finally got to the rooftop, I found this group of monks having an absolutely delightful time. I took out my trusty Globuscope to create a signature 360-degree photograph and their heads started to spin. They had never seen such a device. My presence soon stopped their party and all they could do was

stare at me and the camera. I tried using my hands to explain how the camera worked, but they just giggled! I then motioned them to get back to work, so my photo would look natural. Despite my pleas, they continued to stare at this crazy westerner with the even crazier camera."

Everen is fascinated by man-made structures. However, he also loves to see nature at its wildest. Different subjects appeal for different reasons. He has recently returned from seeing temples and ruins in Myanmar (formerly Burma) that astonished him, but he laments not having enough time to see it all. He has therefore learnt to shoot swiftly, when inspired, running to the centre of his subject to find the best all-round viewpoint.

When out hunting for pictures, Everen finds that certain subjects sing to him, and he instinctively knows where he should be with the camera. Acting on impulse, he can usually find a good viewpoint quite easily, and has only ever pre-scouted a shoot once, for a specific picture in New York's Times Square. He is passionate about wanting you to feel how it actually is to be there, and so the initial positioning of the camera is absolutely paramount. His mission statement reads: "Everen T. Brown photographs all that he sees, for life is meant to be lived in 360 degrees".

46

PREVIOUS

"A visit to this holy site starts by shedding one's shoes and socks. Schwedagon is built on a hill overlooking the city, but the most unique views are inside this stunning complex. You cannot escape the watchful eye of the Buddha. You definitely need a 360-degree camera here, just to capture the intensity of this gilded site."

Schwedagon Temple, Yangon, Myanmar
(formerly Rangoon, Burma)
Globuscope camera
© Everen Brown

ABOVE

"An exploration of the Russian Far East provides an unexpected glimpse into heaven. As our zodiac landing craft worked its way inside this flooded volcanic caldera, I knew I was entering a special world. It is places far and remote like Yankich that keep me on the road, photographing places most will never have the chance to visit."

Yankich Island, Russian Federation
Globuscope camera
© Everen Brown

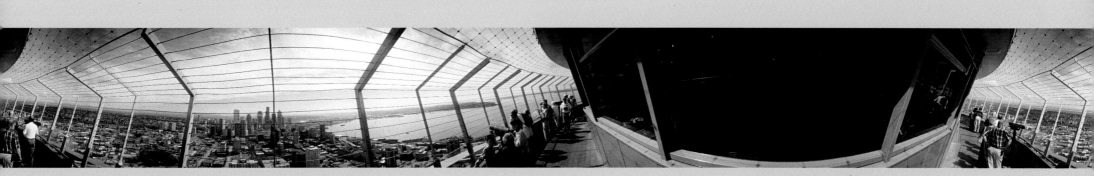

Each time a film is loaded into the Globuscope it must be shot within a few minutes, using up the whole roll of film. There are no batteries in the camera – it is spring-driven and therefore must be discharged within a few minutes from being primed. Everen shoots from several different places, or "nodes", to gain maximum coverage of a scene. The camera can be stopped in increments of 180 degrees, so that if a cloud moves or a bird flies through the scene, it is possible to shoot several revolutions of the camera and edit accordingly later. The Globuscope has two shutter speeds, an "outdoor" speed of one second and an indoor speed of about three seconds, with additional variables possible from adjustment of the lens aperture.

Everen has very clearcut ideas about composing successful 360-degree images. He feels that most rotational photographers don't get close enough to their subject matter. "You have to get deep enough into the scene for the images to really work… the immediacy must leap out". Everen often sets the Globuscope to spin around three or four full rotations to enable easier cropping of the image later. He doesn't believe in showing any more or less than the full 360 degrees, although the actual positioning along the film length is slightly variable. Cropping is very important to him as he likes to present the "story" in the picture to be "read" in the right way. He never manipulates his images.

When asked about exposure and times of day for shooting, he agrees with the majority of swing-lens and rotational photographers that most of his best shots are made around midday, because even exposure is needed across the wide picture areas. Low sun produces flare and deep shadows, and subsequent exposure problems. He tells an anecdote about having to shoot the Egyptian pyramids during mid-afternoon, and how he encountered terrible flare problems as a result of the sun being too low and shining into the lens. Oddly enough, it has turned out to be a very popular image, even though it is "technically terrible".

Everen does not use filtration with the Globuscope, as the camera doesn't allow for it. Similarly, he never uses artificial light. The only time the Globuscope's limitations are a problem is when shooting in low light and at night. Even then he can still shoot in stadiums and arenas. "They have become easier to shoot nowadays, as they are brightly lit for TV". He hardly ever uses a tripod, except if he's shooting for expensive commissions. He prefers to shoot handheld, as he doesn't like to be slowed down by carrying extra weight. The Globuscope's most useful accessory is a two-way spirit level that screws into the base of the camera and is a great help especially when holding the camera above the head. Occasionally, he is tempted to tilt the camera when the subject allows, though he is careful not to shoot wobbly horizons.

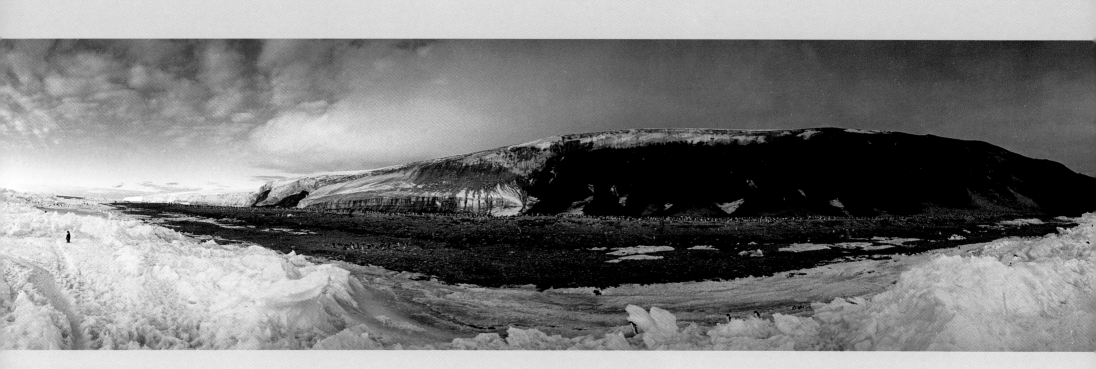

When I asked Everen about his ultimate fantasy camera and what features it might have, his initial response was that he would be interested in being able to shoot 360-degree videos with high quality, but digital storage at present doesn't allow for it. His fantasy camera, strangely enough, turns out to be the Globuscope, "which is near perfect". There is a larger 220 film version of the Globuscope, "which is beautiful, but at almost twenty pounds is far too heavy for climbing and roaming freely". He can keep his freedom with a 35mm Globuscope, as at three pounds it doesn't slow him down, it fits neatly into a backpack, and is "so easy to use you can even shoot from a moving car". Drivers, watch out!

Brown hopes his images of special places will last longer than any "normal" pictures: they contain so much information that it is possible to notice something new and different with every viewing. When he eventually reached the famous ruins of Machu Picchu, high up in the Peruvian Andes, Brown stayed for several days there waiting for the right light for his photography. He passed some time by asking his fellow travellers what had initially drawn them from across the world to this place, and almost without exception the reply was that they had seen an image of it that had compelled them to see it for themselves. This near-unanimous reply confirmed what Everen already suspected about the power of photography to move people. "If you can turn picture-postcard views of perfection into a virtual reality 360-degree view of that special place, then the power of the image will keep them coming to Paris, the Taj Mahal or wherever, forever", he says. Everen T. Brown's legacy can be viewed on his website now and hopefully by many future generations to come.

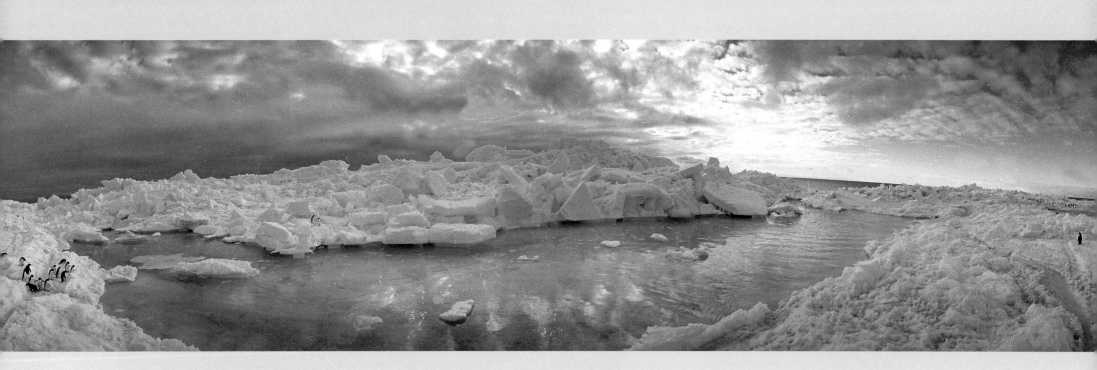

"My trips to the Antarctic are always questioned by those unfamiliar with the incredible diversity of the White Continent. One day it might be a bright red volcanic caldera, and the next day a stunning set of bright blue icebergs. Franklin Island provided this unique view of a "Penguin Swimming Pool". I spent the greater part of an afternoon waiting for the penguins to get ready to dive into their private pool and add that extra-special touch to this magic moment."

Franklin Island, Antarctica
Globuscope camera
© Everen Brown

49

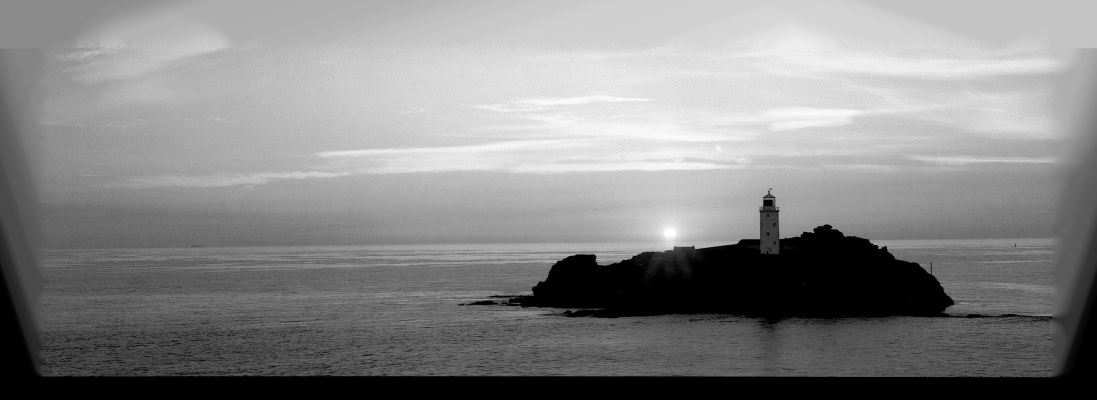

These pictures were made within minutes of each other from the same point, and show how a different mood can be created by waiting a few moments. In the lower picture, after the sun had dropped below the horizon, I changed from the 180mm lens to a 90mm, and deliberately left off the centre-spot filter to gain a vignetting effect.

Nick Meers
Godrevy Lighthouse, Cornwall, UK
Fuji G617 camera
180mm (above) and 90mm (below) lenses
© Nick Meers

useful accessories

There are one or two accessories for panoramic photography that should live in your camera bag, and go everywhere you go. For example, if shooting very wide or 360-degree images, take a good spirit level to attach to the camera or the tripod. This will help avoid horizons that dip or curve – assuming that you are not deliberately distorting them for artistic effect. Some tripods come already equipped with a spirit level built in, and most cameras do not. I find them particularly useful when shooting upright pans, as the eye can often deceive you when looking through the viewfinder.

Centre-spot filter

These filters serve a very useful purpose and help to correct light fall-off from ultrawide lenses on flatback cameras. Simply put, the light travelling through the central part of a lens takes a lot less time to reach the film plane than light coming in at the edges, where it will have to go bouncing around through several glass elements to reach the other side. Believe it or not, the difference in speed can affect the image by up to two, and sometimes three, stops, with the result on the final image being similar to a vignetting technique favoured by old-time portrait photographers. Most panoramic pictures shot without a centre-spot filter display characteristic darkened edges as the light falls off, so in order to even up the light coverage, rather perversely, a dark spot is placed over the centre of the lens. Using one of these filters therefore slows down the exposure by two or three stops, and for this reason many action photographers don't feel the need to use them. The effect of a non-filtered panoramic photograph is not usually too great, except where one is attempting to shoot, say, an even background or a flat area of colour. I prefer to shoot with them permanently attached to my cameras and only remove them when lack of light and impending lengthy exposures dictate.

While on the subject of filtration, it is also worth noting that when using conventional screw-in filters, such as polarisers, skylights and warming or cooling filters with ultrawide lenses, they often protrude beyond the angle that the lens "sees". This will give the disappointing result of cut-off at the edges of your final image if they protrude too far. It is possible to purchase filters in ultra-thin mounts, or better still it is a sound practice to buy filters that are a larger diameter than your widest lens, and use a slim stepping-ring to attach it to the front of the lens. This also enables you to think about the image you are shooting, and not to worry about whether it will show.

Panoramic tripod head

If you are going to attempt to shoot "joiners", a panoramic head is an essential piece of equipment. It is a circular platform that attaches to the top of the tripod, and the cheapest and simplest of these have markings in degrees around them, so that you can easily calculate how far to turn the camera each time you make another exposure. The number of exposures you need to make will not only depend on the width of the panorama you wish to make, but also on the angle of view of the lens that you have selected. Some of the more expensive heads have click-stops at regular intervals on them too, making it easier to be accurate if shooting from a darkened vantage point, for example, where it might not be easy to see the top of the tripod.

Panoramic adaptor bracket

These are quite specialised devices and range from very simple to quite complex engineering solutions. They are brackets that attach between the camera and tripod, with various movements and locking sections, which enable a camera to be placed so that the centre of its lens axis, or nodal point, is directly above the centre of the tripod. Although this might sound a bit too much like fine tuning, it can be a vital detail, especially when shooting close-up panoramas and 360-degree virtual reality "spherical" images. Much has been written about how to find the nodal point of a lens, and each lens is different according to its focal length and other optical characteristics. Broadly speaking, if you can imagine a halfway point between the rear element of the lens and the film plane, you will be quite close, and if this then becomes the point about which the camera spins, then near-perfect panoramas may be shot and will stitch together effortlessly later. Adaptors are very useful with digital cameras, as their compact designs usually place the tripod socket in the base some distance from a central position under the lens. The adaptor helps you correct that.

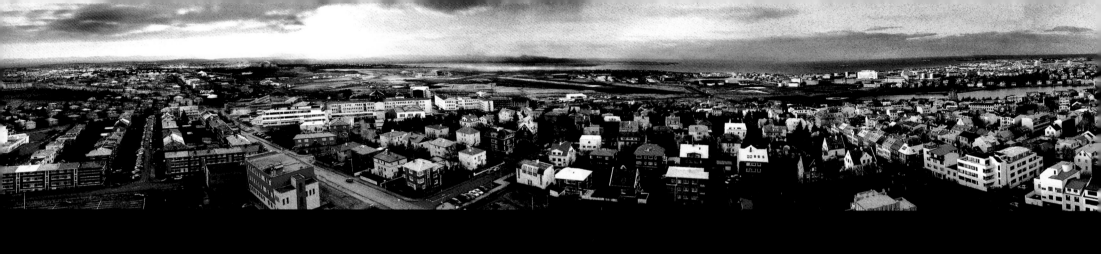

Lens shade or flare buster

Panoramic cameras are more susceptible to seeing flare because of their inherent wide angles of view. It is therefore very helpful if you can do all that you can to keep direct rays of strong light from entering the lens. This is a problem that 360-degree shooters have to live with all the time, and is also why many of them prefer to make pictures on dull and overcast days. Many flatback and rotational location photographers like to shoot at the times of day when the sun is lowest, giving long shadows to emphasise their subjects. This is a perfect scenario to enable stray light to bounce around inside the wide-angle lens elements, creating distracting hexagons of light (or "sunspots") on the final image. If you take the trouble to "wear" a lens shade on your camera, or in some cases, to place a strip of card on a wire attached to the camera, you can save yourself a lot of trouble later. Some photographers use their hand across the lens and others go to great lengths to set up shades

across the camera, but if you try to make sure that the front element of the lens is shaded from direct light, you can be sure of an evenly exposed image later. Some people, of course, like the effect, and strive to get flare in their pictures. I have no sympathy for them!

Henry Reichhold
360-degree view of Reykjavik from the Hallgrims Church, Iceland
(made from twenty-four images using Adobe Photoshop)
HP 715 compact 3.3mp camera
© Henry Reichhold

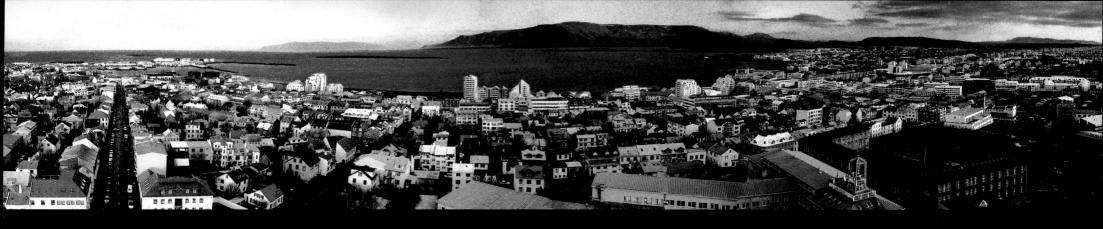

Panoramic film backs

Not listed in the Cameras section are interchangeable panoramic film backs for one or two medium-format cameras. These use conventional 35mm film in a conventional masked-down film back, and attach to the back of the camera in the normal way, taking advantage of the wide covering-power of medium-format lenses. In the case of the Mamiya 7 rangefinder camera, it is possible to obtain a film insert that attaches inside the camera body itself to transport the 35mm film. Another variant on this theme is masking down the inside of a film back with a strip of plastic or metal, or cutting down a large format darkslide yourself, to achieve a panoramic effect. It is possible, for instance, to cut a darkslide in half horizontally, so that theoretically you could shoot two panoramic images in the ratio of 3:1 on a single sheet of 4"x5" film. You would of course need to load it into the camera after mounting the darkslide on the camera and exchanging it with the conventional slide to avoid fogging the film. I used to carry a masked-down 6x12cm rollfilm back for my 4"x5" field camera, specifically to be able to shoot 3:1 ratio panoramics on 120 rollfilm, the lower part of the processed film appearing as a black strip. It also had the added bonus that it gave a type of perspective control to the image, as it would offset the image vertically without the need to employ a rising lens to keep buildings from appearing to lean inwards, an architectural trick that is of some interest to panoramic photographers. The Linhof Technorama 612 has a built-in offset lens for the same purpose.

panoramic masters: macduff everton

Macduff Everton maintains that he got involved in photography almost by accident as a seventeen-year-old. He had left his native California to travel around Europe and Asia in the 1960s. "During my travels I saw an American guy take his camera off, put it down in the street and walk away, saying he didn't want to look like a tourist any more. I picked it up and ran after him with it, but he said I could keep it". Macduff started taking pictures with his new acquisition, a Kodak Pony, and continued his travels, occasionally sending his slides home for approval and advice from his father. When he reached Japan, Macduff sold his first picture stories on Burma and South-East Asia. Suddenly, he was a professional. Now, decades later, his work is held in private collections, and in numerous galleries, and he is represented by Janet Borden in New York, who also represents Martin Parr, Lee Friedlander and others.

Macduff's background is as a painter. He has always been interested in changing light patterns and how it affects what he sees. His parents used to take him to art galleries and he developed a liking for the works of Constable, Turner, Vermeer and the Impressionists, and how they captured moments of exquisite light. He remembers going to a Van Gogh exhibition in San Francisco as a seven-year-old, and seeing a picture with ivy in it; he was blown away by the detail and how, when you were close to it, it was "just a bunch of blobs, and yet it came into sharp focus as you stepped further back". He was "captivated".

Having grown up in Oregon and California, spending much of his time outdoors, Macduff had always paid attention to the weather, because of his dependency on it. When out on horseback high up in the mountains, it was essential to be aware of rivers rising, clouds coming down, nature having its way, and he learned to look for nuances in the changing light from an early age. When he returned home from his backpacking adventures, Macduff saved up for his first "real" camera, a 35mm Pentax Spotmatic and two lenses. He started doing photojournalistic work, mostly in black and white. He got a job with an educational film company who sent him to Mexico to take anthropological pictures. In 1969 he began a personal project of archaeological and other pictures in Yucatan, Mexico. He did various short-term jobs to fund this. He was a white-water river guide, a cowboy, a mule skinner and a wrangler in California and Oregon. As soon as he had saved enough money, he'd return to Mexico. More than twenty years later, in 1991, his book "Modern Maya" was published to great acclaim.

Macduff was drawn towards the panoramic format to better explain the visual situation of where his pictures had been taken and to give a sense of space. Often, he would take three days to walk into a remote site to make pictures, and upon getting home, realise that the pictures weren't giving the full information. They were showing only a small segment of the place he had been to, and even with his widest-angled lens on a 35mm camera, it still wasn't wide enough to fit it all in.

He purchased his first 35mm Widelux panoramic camera in 1986 and took it to Yucatan, where he shot in black and white. His addiction to swinglens cameras had begun. Macduff argues that the only true panoramic photographs are those that mimic the human vision, and the swinglens camera comes closest to that ideal. The 150-degree swinglens covers normal human peripheral vision, he maintains, whereas other (flatback) cameras are merely shooting in the letterbox format, an effect that could be achieved simply by cropping the top and bottom from a conventional picture format. Macduff's first forays into colour came about as the result of a suggestion from a friend that he should try it. In 1986, he took a few rolls of colour negative film with him on a walking trip to Scotland and the English Lake District, with great success. The colour prints from that trip fired him up, and he started to work for Condé Nast's *Traveller* magazine almost immediately. The wide view afforded by the panoramic format convinced him to continue shooting in colour, as it opened up scenes that had previously been restricted by "normal" 35mm cameras. He has now produced so much colour work in this format that few people even remember his black and white photojournalist stories.

He continued to work with Widelux cameras, and had several that always seemed to have loose screws and needed repairing. After getting through eight Wideluxes, he was lent a 6x12cm Noblex by Kornel Schorle, who had helped to develop it, and he transferred his affections to the Noblex almost immediately. An early indication of its rugged qualities became apparent when it fell about four feet onto a marble floor and it carried on regardless.

Macduff likes to travel light and goes everywhere with his trusty 120 Noblex and a small 35mm Nikon outfit. Having only six shots per roll on the 120 Noblex is slightly restricting when out shooting, so for backup he also carries a 35mm Noblex, which takes nineteen frames on a roll of 35mm film. There have been times when, for instance, he has needed those extra frames on the 35mm, such as when shooting from a helicopter in the Himalayas and his fingers were too cold to change films. His assignments usually dictate the places that Macduff travels to, and his personal work allows him journeys to other places. He finds that he is often commissioned by magazine editors who prefer a fine-art approach to travel photography. Because of the restrictions while working on commission, he prefers to shoot his personal work in his own time.

I asked him if he ever sets out with any preconceptions about composition, if there are things he would try to achieve, or things he would never do. "No! Rules are there to be broken, laws are to be obeyed, and there aren't that many rules", he replies. He does concede, though, that some photographers have difficulty composing within the wider panoramic frame. "With most conventional

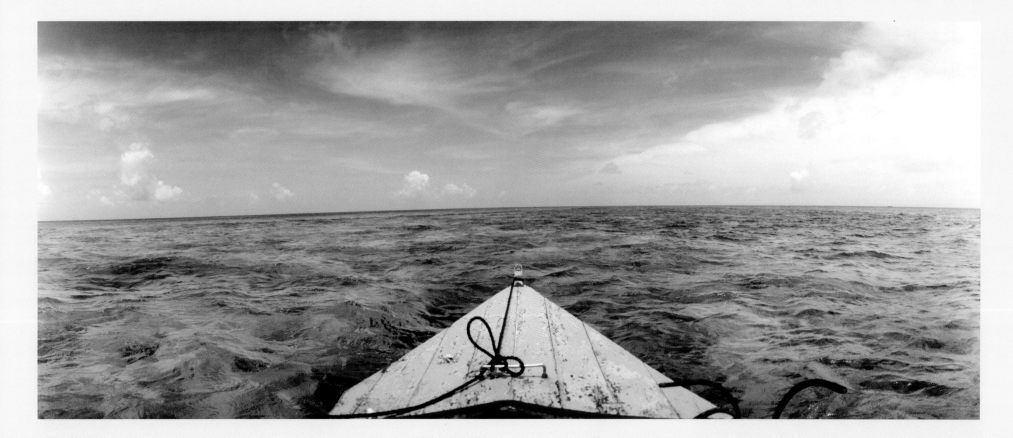

Mundo's Bow, Isla Providencia, Colombia, 1993
Noblex 120
Fuji NHG II film
© Macduff Everton

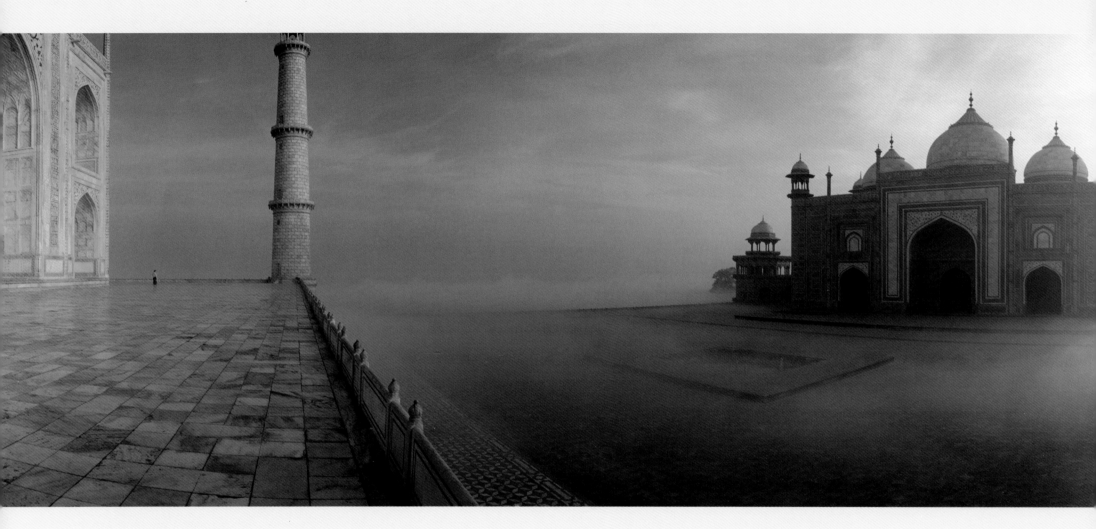

The Taj Mahal, Agra, India, 1993
Noblex 120
Fuji NHG II film
© Macduff Everton

photography it is very easy to lose peripheral vision", he says, "and most people new to the panoramic format make the mistake of putting everything in the centre of the picture frame, and forgetting about the edges. It is most important to watch what's happening at the corners, you really do have to pay attention to everything".

When asked about his preferences for colour film, Macduff likes to use the fast-speed Fuji NPZ 800 negative film, because he prefers to handhold everything, even down to 1/15th second. He'll only use a tripod when he really has to. Another advantage of NPZ is that, as a so-called "wedding" film, it has good pastel tones. He prefers the subdued palette of NPZ negative stock to the brighter tones and contrast, for instance, of Velvia transparency. Colour is something he puts a lot of thought into. For this reason, he feels that the most successful painter of the tropics was Paul Gauguin, who used pastel colours in his work.

Macduff is often asked if he uses a computer to enhance his colours and answers that those who think his colours have been manipulated are usually those who haven't spent long enough in nature to recognise that they are natural. He prefers to print all his own work in the darkroom as he feels that most printers spend too much time inside and aren't familiar enough with all the different colours of light throughout the day. He makes gallery prints up to 30"x40", and his commissioned work is mainly submitted as 11"x14" work prints, from which high-end scans are made by magazines.

By sticking to only one film, he instinctively knows his light readings without having to use a meter. He usually calculates for the shadow areas, which he doesn't want to block up. "You can always print a sky down, but you can't bring the shadows back up if they are not on the negative", he says, "and when you're covering a width of 150 degrees, there is often a difference of up to three stops across the picture area, which can be retained using the latitude of negative film".

Macduff has learned not to be too keen on filtration: "The Widelux filters were only good for black and white film – there was an orange, a yellow, and a red, but they didn't always stay on". Because of their unreliability he gave up on them, and nowadays doesn't use them at all. "If you are prepared to wait for the light to be perfect, you shouldn't have to use filtration". He likes the point-and-shoot aspect of the Noblex, which gives him good speed to shoot fast and react to swiftly changing light conditions without the need for filtration. Lighting is something else he prefers to live without. He has used additional constant lighting when shooting architecture, though not often. It is not practicable to use flash (strobe) lighting with a swinglens camera, due to the extended lens rotation times.

When asked if there might be a special kind of camera that he would like, which hasn't yet been invented, his answer is an immediate: "Yes, a 35mm version of the Noblex that's indestructible. The present 35mm version is simply not built as well as the 120 6x12cm version." He maintains that 35mm film is easily acceptable for quality: Macduff's work from the 35mm Widelux has been blown up to sixteen feet wide and exhibited at the Metropolitan Museum of Modern Art in New York. Another item on his wish list is an underwater housing for the 612 Noblex, as he already has one for the Widelux – not necessarily for diving deep with but to get "over-and-under" pictures in the water. Everton attempts to shoot landmarks in a way that hasn't been captured before. He tells about meeting a man who had seen, in a local exhibition, one of Everton's unusual pictures of a place near the man's home, and despite having lived there all his life, the man had never seen it that way before. This was perfect for Macduff, who gets great pleasure from bringing a fresh viewpoint into people's lives. The panorama is for him the best format for giving the sense of a place, especially for travel work.

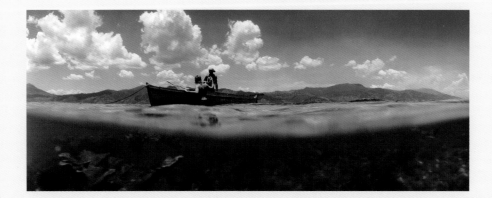

For his underwater Widelux shots, Everton uses a unique housing and shoots on Kodak Gold film, as he can't use a fast film with that camera.

Cayo Blanco, Honduras, 1991
Widelux in underwater housing
© Macduff Everton

The first dawn of the new millennium: "The typical thing, I had to leave at 4am to reach the coast for sunrise, and wasn't sure if it would turn out OK. It did."

Millennium sunrise, International Dateline, Taveuni, Fiji, 1999
Noblex 120
Fuji NHG II film
© Macduff Everton

panoramic masters: josef koudelka

Josef Koudelka, born in 1938 in Czechoslovakia, is a key figure of twentieth-century documentary photography. His powerful work is often cited as a major influence by photographers. What is more surprising is that Koudelka has chosen to work in the panoramic format for many of his major award-winning projects around the world. He started to use a panoramic camera in 1958, but it was not until the mid-1980s that the format became central to his work. Koudelka established his reputation with his emotive pictures of the invasion of his homeland by the Soviets in 1968. He didn't wish to be identified as the author of his own work when it was published all around the world, for fear of reprisals to his family, who were still living there.

A friend of his father's, a baker, first introduced him to photography when he was about fourteen years old. He went on to study engineering in Prague and during this time bought a Rolleiflex to pursue his interest in photography. Around 1961, aged twenty-three, while working as an aeronautical engineer, he became a freelance photographer for a theatre magazine, and simultaneously began to photograph Gypsies, a subject he was to return to many times. He travelled to Eastern Slovakia to photograph religious festivals, and had his theatre pictures published in his first book in 1966. The following year, he received an award for the innovative quality of his theatre pictures, exhibited his photographs of Gypsies for the first time (in Prague), and resigned from his engineering job to become a full-time photographer.

He photographed Gypsies in Romania in 1968, the same year that Czechoslovakia was invaded by the Warsaw Pact countries. Koudelka photographed the bitter daily confrontations between Czechs and Soviets in the streets of his home town, Prague, producing a body of awesome work. His pictures were smuggled out of the country to the United States, where Elliott Erwitt, then president of Magnum, arranged to publicise and distribute them more widely to the major international news magazines. He was awarded the Robert Capa Gold Medal by the Overseas Press Club for his extraordinary pictures. He left Czechoslovakia in 1970 on a three-month exit visa to photograph Gypsies in the west, and didn't return. Having been granted asylum in England, where he was to live for the next ten years, Koudelka began to travel more widely in various European countries. It was not until sixteen years later, after the death of his father in 1984, that his photographs of the invasion were published under his own name at last, and it was not until 1990, a full twenty years after he left his home country, that his pictures were exhibited in Czechoslovakia for the first time. He was invited to become a full member of Magnum in 1974. In 1975, he had a solo exhibition of his work at the Museum of Modern Art in New York, and published French and American editions of his now-famous book simply entitled *Gypsies*, which was awarded the Prix Nadar in 1978.

Koudelka left England to live in France in 1980, and continued to travel throughout Europe. A little later, he started to document urban and rural landscapes in France, and started to use a panoramic camera more in his work. Throughout the 1980s, he had several large exhibitions of his work in Prague, London, Paris and New York, that travelled throughout the United States and Europe. He became naturalised in France, won more major awards, and published another book, *Exiles*, to much acclaim.

In 1990, in addition to the first showing of his work in his native Czechoslovakia, Koudelka set out to photograph the devastated landscapes of the Ore Mountains in Northern Bohemia. The ravaged land became a theme he returned to often, and paradoxically his images contained fewer pictures of people, but more of the destructive effects of man and the desecration of his environment. Koudelka photographed war-torn Beirut with his panoramic camera in 1991, winning the Henri Cartier-Bresson Award, and several other awards, for his work. He published a book on the landscapes around the Ore Mountains, and went on to document the ruined landscapes of Saxony, Poland and the Czech Republic, making some extraordinary images of the industrial exploitation of the land by strip-mining. He was commissioned to shoot some panoramic images in South Wales in 1997, and in 1998 the Royal Photographic Society awarded Koudelka the Centenary Medal for his "sustained significant contribution to the art of photography".

In 1999, *Chaos,* a work in which the world seems devoid of humans as a result of the devastation they have caused, was published. It is a remarkable body of work, entirely in the panoramic format, which shows documentary photography at its finest. His compositions are always unusual and feature stunning visions of strange juxtapositions of surreal subjects. Although he works as a documentary photographer, Koudelka is not concerned about narrative. His work now leaves people out of his panoramic images except where they lend scale or poignancy to an image. His pictures show us houses gutted by war, land devastated by mining and pollution, the processes of decay and destruction, but always with his innate sense of composition. His vision makes order out of the chaos he sees all around him, his compositions always immaculate, perfectly balanced and brilliantly observed. What matters most to Josef Koudelka is to continue taking photographs without repetition, and what matters to us is that he has shown us that it is possible.

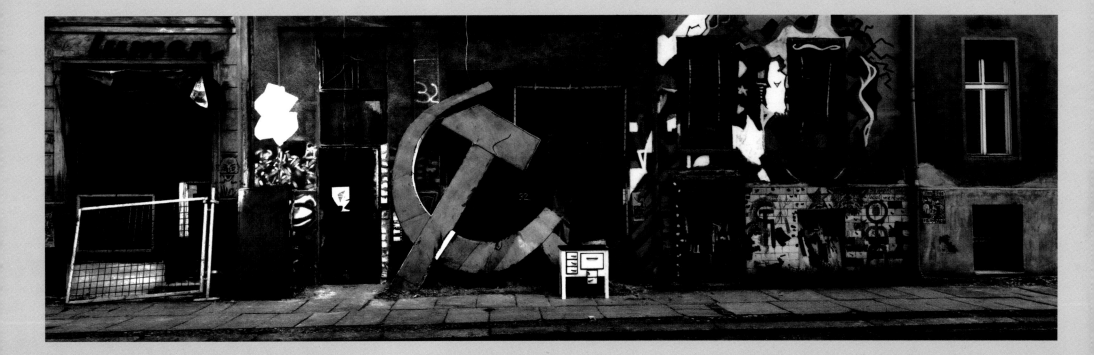

West Berlin, Germany, 1990
 Fuji G617 camera, 105mm lens
© Josef Koudelka/Magnum Photos

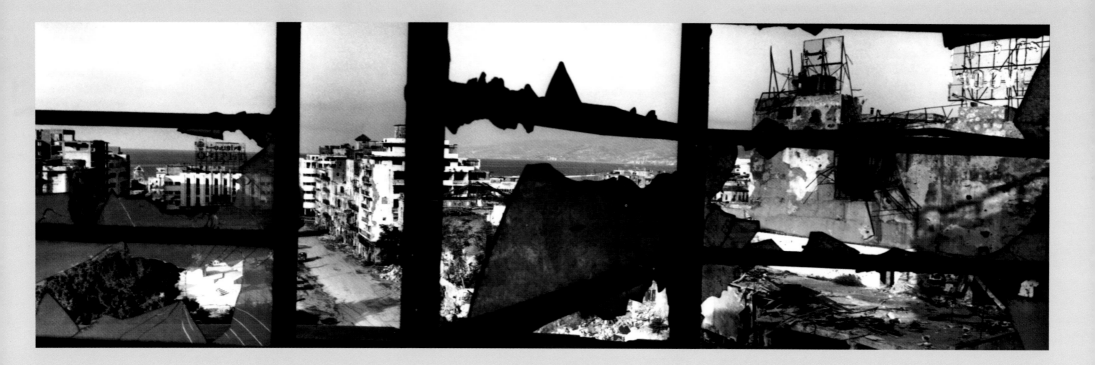

62 Canon Square, city centre, Beirut, Lebanon, 1991

Fuji G617 camera, 105mm lens

© Josef Koudelka/Magnum Photos

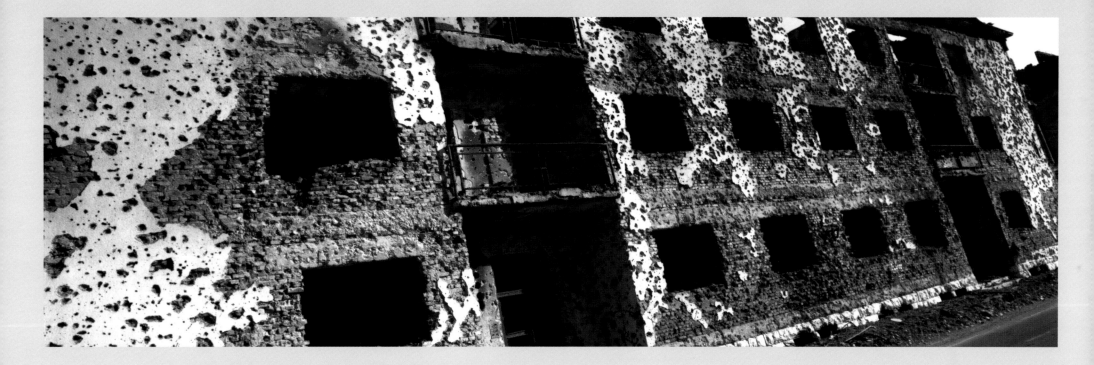

Muslim quarter of Mostar, Bosnia-Herzegovina, 1994
Fuji G617 camera, 105mm lens
© Josef Koudelka/Magnum Photos

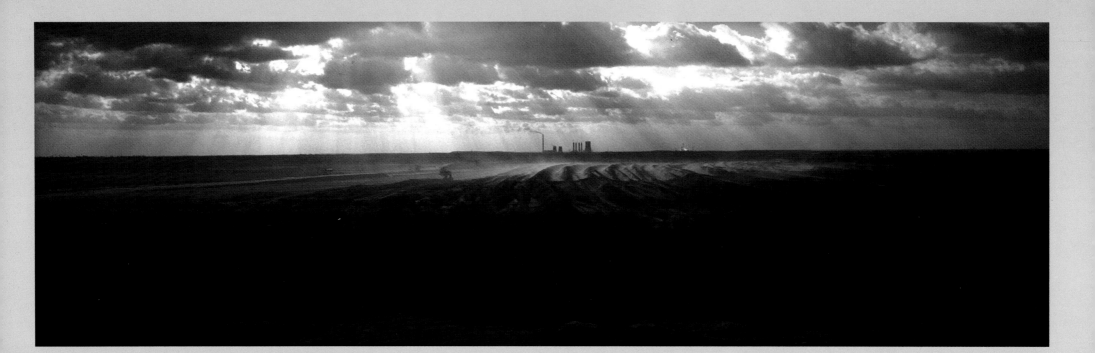

64 Open-cast mine with newly built power station,
 Saxe Espenhain near Leipzig, Germany, 1997
 Fuji G617 camera, 105mm lens
 © Josef Koudelka/Magnum Photos

Northern Greece, 1994
Fuji G617 camera, 105mm lens
© Josef Koudelka/Magnum Photos

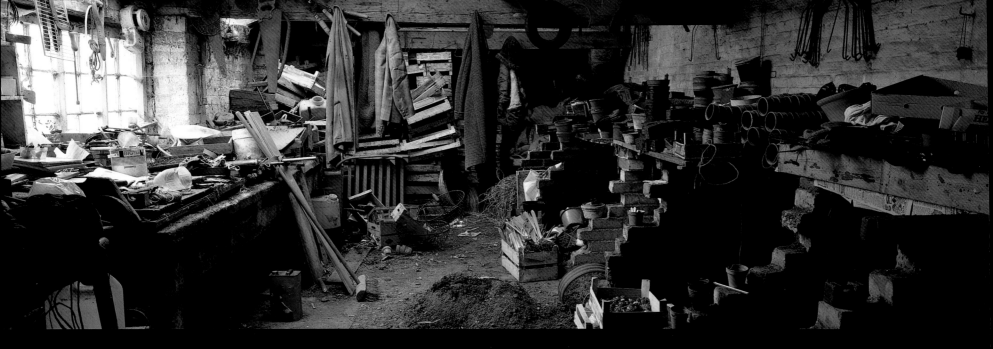

This was shot to illustrate the "backstage" feel of a large garden
for my book *Panoramas of English Gardens*, and shows how
the panoramic format can also be successful for interiors: I
moved nothing for this composition, which makes the eye travel

Nick Meers
Potting shed at Flintham Hall, Nottinghamshire, UK
Fuji G617 camera, 105mm lens
© Nick Meers

One of the first things to understand about panoramic photography is that it isn't all about vast wide-angle views of landscapes and group shots of schoolchildren. The very word "panorama" seems to create a preconception in some people's minds that equates to "wide views". There are very few successful panoramic photographers out there, and those who do succeed have taken the time to really think about their pictures before setting up the camera and have been extremely careful about their compositions. To state the obvious, the film area is very large, which implies, among other things, that you don't get many shots on an expensive roll of film. Don't waste it, this isn't the type of photography where you can shoot a hundred frames in the hope that one or two will turn out right. You'd better have a good look around first.

Much is discussed about the often-mentioned "Rule of Thirds" in conventional photography, and one's eye does inevitably get drawn to certain parts of a picture area – unless the composition has got something very different to say. The rule of Thirds is based on the notion of an "ideal proportion", and how subjects can be arranged within that space, positioned judiciously at places that fall one-third in, or one-third up, or one-third down from the edge of the image. Many words have been written on how the "Golden Square", a slightly elongated square roughly equivalent to the 4"x5" format, makes for great compositions due to its pleasing proportions, which naturally has nothing whatever to do with the panoramic format. Rules are, of course, there to be broken, and as long as you know which rule you're breaking, you shouldn't have too much trouble with panoramics.

The first thing to bear in mind is that we are not simply dealing with a stretched area that's noticeably longer than normal. There are many dynamic ways to fill a letterbox-shaped frame, and much larger distances to make the eye travel to obtain full information from the picture. Use that space. It doesn't have to be crammed with information, it can be very quiet and empty, but the dynamics of where you place your subjects within the frame are often overlooked.

Make it interesting for the eye to journey around the picture, to want to explore all that space and return to where it started. It's perfectly fine to have a huge area of "nothing" or of only one colour, if it is there for a reason; to balance what is on the other side, or to contrast with something else. Study the images in this book and ask yourself what makes them interesting. With some, it could be the subject matter, but with others the subject is immaterial because it's the composition that grabs you

Some photographers use graphic devices to draw the eye into a picture – strong diagonal lines leading into the corners are an obvious example. Placing objects in front of, or next to, large areas of colour or interesting shapes is another. Many photographers make the mistake of placing their subject matter too centrally, and not being bold enough to use the space towards the edges, and this is easier to do with the panoramic format. The most ineffective compositions in the panoramic format look as though the camera seems to have taken more in than originally intended, with everything piled up around the middle and not much happening at the edges. Look at Josef Koudelka's pictures, however, and you will notice that he often places his subjects centrally, yet achieves extraordinary dynamics with the delicate balance of his compositions. He is the only photographer that I have seen achieve great compositions with centrally placed subjects, because he is not afraid to use all of the rest of the space to awesome effect.

Some people maintain that they wouldn't know a well-composed picture if it bit them, but if you put it another way, it's very easy to recognise a badly balanced picture. With panoramas, it's easier to tell across that wide area, so you must take even more care when setting up the camera. If you place a strong subject in the dead centre or along the central line of a picture, it will probably impede the eye's progress around the picture, and thus prevent an easy journey.

Running lines of composition into the corner of a picture is sometimes a very effective way to draw the eye into the scene, especially when there is not much else to include. Balances of light and shade, dark and light, near and far, echoes of similar shapes, are all things to look out for. Watch out also for things that you definitely do not want to include in your picture, and take steps to keep them out: That small extra effort of moving a small distance to one side at the time, or hiding an unwanted object behind something else, will all be worthwhile. Make sure you have a good look around your potential picture and check what's happening at each of the corners before you press the shutter. Good compositions usually have to be worked at.

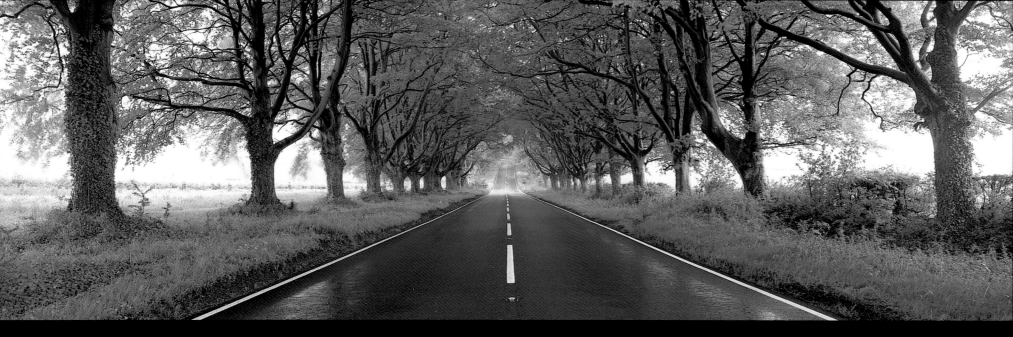

LEFT

There are more tulips grown in this part of England than there are in the Netherlands, and this picture was shot to illustrate the idea of tulips growing off beyond the horizon. While the composition is very simple and graphic, I had to wait until the sun had moved around to fill the dull and distracting earth between rows with strong black shadows, just enough to highlight the colours all around.

Nick Meers
Field of tulips near Spalding, Lincolnshire, UK
Fuji G617 camera, 105mm lens
© Nick Meers

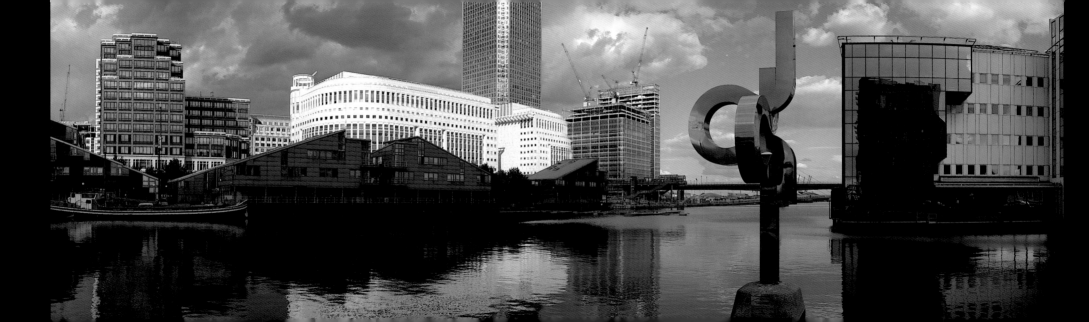

These two images of William Henry Fox Talbot's home were shot from the same place. I included the famous oriel window, which was the subject of one of Fox Talbot's earliest images, as a kind of tribute to him, while using an early version of my self-made Z-Pan camera. The smaller image was shot with a 90mm lens to show the building's setting. By simply changing the optics to a 600mm lens, I filled the frame (above) to "flatten out" the building into a more graphic series of shapes, showing the larger oriel window (fourth from the left).

Nick Meers
Lacock Abbey, Wiltshire, UK
Z-Pan 6x17cm
© Nick Meers

In composing pictures for the panoramic format, I'm not implying that you should only use wide-angle lenses. The important thing is to make the dynamics of a picture work within this shape, whether it's in the ratio of 2:1, 3:1, 4:1 or beyond. I enjoy using long focal length lenses within the panoramic format, as they tend to flatten the perspective and thus emphasise the graphic patterns within a composition. The compression effect works particularly well in the "letterbox" shape, so much so that I think it's almost more difficult to compose with an ultrawide than with the luxury of an extreme telephoto.

Take your time. Hopefully you'll be making images that'll be around for a good while to come, so have a good look around the edges of the frame to make sure you're not including any unwanted power lines, tourists in red hats, TV aerials or gasworks. If you shoot too fast without looking intelligently at your subject, you'll get caught out. Shooting with a tripod is by necessity a slower job than you might be used to, but there are very few pan photographers who can "shoot from the hip" and know that what they're getting will be good. There are so many ways to shoot pictures, and so many types of panoramic photographs to shoot, and the whole world out there that needs recording in some form or another, that it is a hopeless task to be dogmatic about composition.

"The Golden Rule", as George Bernard Shaw once said, "is that there are no Golden Rules".

Do look carefully at your subject matter. Do notice everything around you. Do try to get an interesting angle. Do think about what you're doing, and do make images that'll stand the test of time.

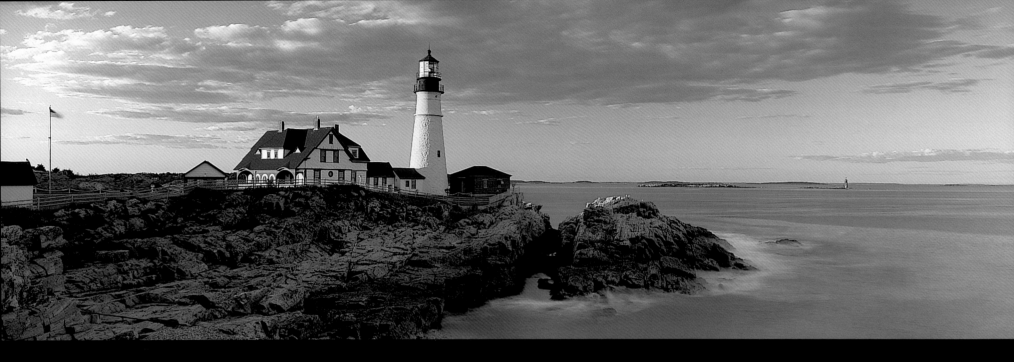

These two pictures, made within half an hour of each other, illustrate how a "static" landscape must be watched for critical lighting in constantly changing conditions, and how the lens' focal length can affect a composition. In the upper image, I was more interested in the shadow details of the rocks, and made my exposure reading for the shadows. In the lower image, I changed lenses to tighten up the composition, and waited for the last warm evening glow on the lighthouse, before squeezing the shutter.

Nick Meers
Portland Head Lighthouse, Maine, USA
Fuji GX617 camera, 90 and 180mm lenses
0.6 ND graduated filter, Fuji Velvia film
© Nick Meers

One of the joys of panoramic photography is that the massive
area of film easily gives enough room to have two or more
pictures within a picture: this is a portrait of a tiny blue harebell
growing from the huge stones of a thousand-year-old wall in the

Nick Meers
Hadrian's Wall, Northumberland, UK
Fuji G617 camera, 105mm lens
© Nick Meers

In order to see the unusual shapes of the rocks more effectively,
I wanted them to still be wet from the receding tide. This picture
was therefore made with reference to the local tide tables, which
governed what time of day to shoot! Notice also the upright ruins
of the distant castle, achieved by shooting with a field camera

Nick Meers
Dunstanburgh Castle, Northumberland, UK
Linhof 4"x5" camera with 6x12cm film back, 90mm lens
© Nick Meers

panoramic masters: benjamin porter

When Benjamin Porter decided to take up photography, his head was turned by a pair of Czech photographers, Josef Sudek and Josef Koudelka. He was inspired by their grip on reality and their strong compositions. Koudelka's work stood out not only for his (more recent) panoramics, but also his earlier work on Gypsies and this consolidated Porter's resolve to go out and take more pictures. No stranger to imagery, Porter has been making photos since he was eight years old. He dabbled in painting while at college, but always preferred photography. He is passionate about the history of the medium, and there's a challenge for him in continuing that history. Towards the end of the 1980s, he wanted to experiment with the panoramic format. He managed to get hold of a 5"x7" view camera, and decided to block out half of the film darkslide, thus creating a panoramic format for his picture-taking. He kept seeing late nineteenth- and early twentieth-century panoramic photographs around his local area in North Carolina, and was very impressed with the work he saw. After much research, he discovered that the creator of these images was Herbert Pelton, who lived from 1878-1956, and worked with a Cirkut camera. Porter decided to try to emulate some of Pelton's original work, and eventually found an old No.8 Cirkut camera to replicate the old views of people and local scenes. Finding the eight-inch-wide film needed for the Cirkut wasn't a problem as Kodak's Verichrome Pan black and white film was still commercially available.

Benjamin shoots panoramics for business and for pleasure, although he shoots somewhat different styles if he's not working. He finds that the more commercial group photographs, by their very nature, have to be controlled to a certain extent, so his personal work tends to be more off the wall. He likes to use the Cirkut in ways it was perhaps not originally intended, and tries to achieve motion blur by using it in non-commercial settings, working like a street shooter. Panoramics account for about half of his output. His personal creative work is intended to be exhibited in galleries and in publishing, and his commercial work is mainly for the various groups of people who have commissioned him. The enormous size of the Cirkut hasn't stopped him lugging it around the world, carried whenever possible as hand luggage. He's shot in South America, Eastern Europe, North America, and most recently in India. The Cirkut camera was originally designed to shoot groups of people, and Benjamin loves to shoot celebrations, rituals, events, and gatherings of all descriptions. He is fascinated by the chemistry that happens when large groups of whatever description are assembled. In some foreign countries, South America for instance, he finds it's always a challenge to make photographs, as people don't always understand that the old Cirkut is actually a camera. "Shooting large groups is very challenging. Panoramic composition is very different to normal composition. When setting up, I always take great care of the edges – they are as important as the central area. The boring panoramic work, done by people who don't know what they're doing, tends to end up with central compositions in the centre of a large wide space". He therefore encourages groups of people to spread out as much as possible to create a more relaxed portrait, and then sets the camera to rotate accordingly to fit the group. The Cirkut camera has a spring-driven motor which rotates the camera as far as you want the picture to expose, so the length of film used and the angle of view, is entirely controlled by the photographer. The No.8 Cirkut's negatives are always eight inches wide by whatever the length turns out to be, sometimes about forty feet long, depending on the size of the group, and how many degrees the picture encompasses. A full 360-degree view uses more than five feet of film.

For a good printable negative across a wide area, exposure is very important. "Lighting is critical, and needs to be paid attention to". When shooting, Porter uses a modified zone system to enable better contact prints later. A top tip he picked up from Harold Lewis, a panoramic photographer from the Boston area, has helped him when shooting group photos: he often shoots into the sun, against popular wisdom, because people's faces are more relaxed when slightly backlight. His exposure readings are therefore taken from the dark side of his subjects, and printed later accordingly, to great effect. Benjamin hardly ever uses filtration, though occasionally he uses a yellow filter when shooting landscapes in black and white, to darken down the sky. Additional lighting on location can sometimes be difficult, as he finds it usually creates more problems than it solves. It is possible to light a rotational panoramic picture with a continuous light source strapped to the top of the camera, but it produces a garish effect that he prefers not to use.

Benjamin's most unusual accessory is a very tall tripod. He uses an old tripod which extends up to twelve feet high, which he reaches with the aid of his trusty fourteen-foot stepladder. When asked if there is a special kind of camera that he would like, which hasn't yet been invented, the answer is an updated version of a Cirkut, without the need for maintenance. He used to own a small Roundshot camera built along the same principle, and now has a 6x12cm Noblex, mainly as a backup for the Cirkut, which can be less than reliable. Whenever possible, though, Benjamin still prefers to shoot with his trusty old Cirkut, as he particularly likes the superb quality of contact prints taken from its enormous negatives, a quality admired by all who have seen them. Bigger is not necessarily better; it is the quality that is the most challenging and important part of Benjamin's work.

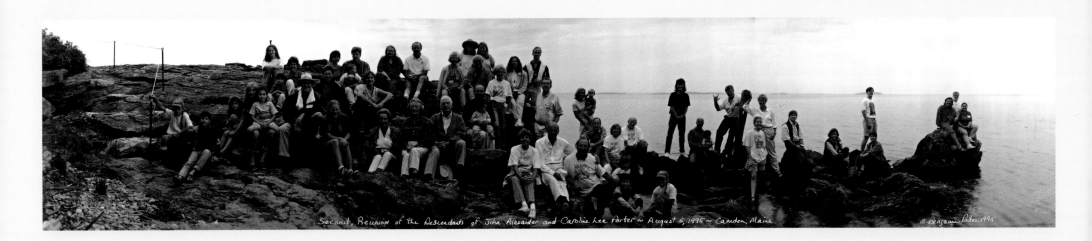

Second Reunion of the Descendants of John Alexander and Caroline Lee Porter ~ August 5, 1995 ~ Camden, Maine © Benjamin Porter 1995

The Descendants of John Alexander and Caroline Lee Porter
(reunion panorama of Benjamin Porter's family, which gathers
together once every three years), Camden, Maine, USA, 1995
Cirkut No. 8 camera
© Ben Porter

78

"This is a colour panorama depicting a gathering of very special (and rare!) automobiles at Biltmore House in Asheville, NC. We had to start setting it up in the early morning hours when it was still dark as we had to be finished with the photograph by 9am. The cars were lined up in concentric semi-circles so that they would appear to be in a straight line in the photograph. The value of the cars on the lawn is about US$28 million!"

Convention of the Gull Wing Group (Mercedes) International,
Asheville, North Carolina, USA, 2000
Cirkut No. 8 camera
© Ben Porter

Lake Eden
Black Mountain, North Carolina

BLACK MOUNTAIN COLLEGE REUNION
October 28, 1995

© Benjamin Porter 1995
Asheville, North Carolina

"This was the one and only reunion held of the alumni of Black Mountain College, an influential avant-garde school of art, dance and writing, which operated near Black Mountain, North Carolina, from roughly the 1930s to the 1950s. Many influential artists attended the school, which played a pivotal role in the American art scene. Some of the famous alumni who attended or taught at the school include John Cage, Josef Albers, Merce Cunningham and Robert Rauschenberg."

Black Mountain College Reunion, North Carolina, USA, 1995
Cirkut No. 8 camera
© Ben Porter

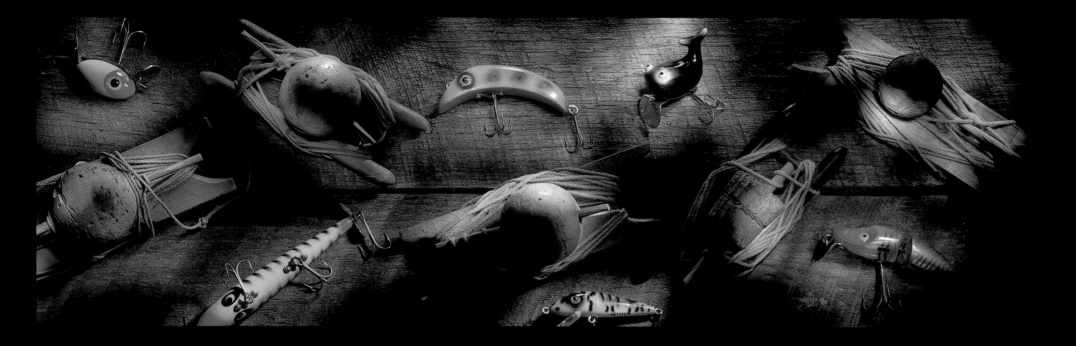

80 This shot was made possible by the invention of a very special camera, the "V-Pan", a 6x17cm monorail camera that allows interchangeability of lenses and bellows that work with focal lengths from 90 through to 1200mm. Because of the variable bellows, it is also possible to shoot close-ups, here shown to great effect by the camera's inventor and maker.

Chet Hanchett
Still life with fishing lures
V-Pan 6x17cm camera
© Chet Hanchett/Panoramic Images

exposure

Exposure is one of the most vital ingredients of making a picture, and can be as easy or as complex as you wish to make it. Some photographers place great emphasis on shooting a perfectly exposed transparency or negative, and others shoot negative materials precisely because they don't wish to be bothered, as they rely on the greater latitude of the film to help them out later at the printing stage. Making a correct exposure at the time of shooting is always good practice and can save you a lot of time and expense at the printing stage. Making the right exposure for a panoramic image should not necessarily be any more difficult than for a smaller format, except that, in many cases, you will have to assimilate an obviously larger field of view before you make your calculations.

When I studied photography at art school more than a few years ago, I assumed that because I had a perfectly good meter inside my trusty Nikon, and it always seemed to turn out decent results, I need not bother too much with learning about light meters. Of course, the moment I left college and went out into the world to shoot pictures for a living, I came across many different lighting situations where my Nikon could obviously not cope, and I wish I'd listened more when I'd had the chance.

A general tip on taking readings is to be aware of the variants of light and shade that you will be trying to capture on film: this is known as the Image Brightness Range, or IBR. Each film has only so much latitude to capture all that information, and you will in time get to know how your favourite film reacts in soft or hard lighting situations. Be aware of the IBR in an extremely wide picture and bear this in mind when you consider your composition, and where to shoot your picture from. If you look at Everen Brown's 360-degree vistas with this in mind, notice how in his Burmese temple panorama, for instance, he has artfully concealed the too-bright light source of the sun behind a tree. Convenient? Or did he place himself and the camera in its shadow? Benjamin Porter's tip about shooting large groups of people into the sun, to avoid scrunched-up faces, is also worth remembering, as it might affect how and where you set up your composition, long before your light meter comes out of the camera bag.

Nowadays, it is possible to purchase meters that combine the specialised functions of a general meter, a spot meter and even a flash meter. These offer great versatility, but even a fairly basic meter will enable the user to take accurate light readings in the vast majority of situations. There are four different methods involved in taking light readings. The first three of these involve using a handheld meter: reflected light readings, incident light readings, spot meter readings and readings taken from built-in meters. Let's look at each in more detail.

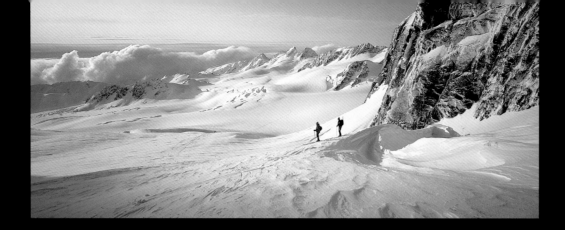

Reflected light readings

These are made, as the name suggests, by reading the light reflected back from the subject matter. You simply set up your meter with information about your film speed and point the sensor in the direction of your subject. It is a good indicator of the general level of brightness around you, and many photographers like to take their readings by using this method. Unfortunately, in certain lighting conditions, this method can trip you up badly and mislead you to the extent of ruining your photograph completely. Consider, for instance, how bright snow can be, and how dark earth can be. You might even find the two of them together under the same sun and point your meter at one, then the other, and you will find wildly different reflected readings. This is the classic dilemma that was taught to me as the "black cat in a coal hole or polar bear in a snowstorm" situation, referring to the extremities of brightness that would mislead a reflected reading. For this reason, some photographers always carry with them a grey card with exactly 18% reflectance, mostly referred to as a "Kodak grey card", from which they can reliably judge the reflectance for a "true" reading in many different lighting situations.

TOP LEFT AND LEFT
These two images show the extremes of subject brightness that can occur, both of which are equally likely to mislead a reflected light meter. An unmodified reflected reading would have led the meter to suggest an exposure that would have turned the snow into a mid-grey tone (as it is programmed to do) resulting in underexposure.

Andris Apse
Upper Neve of Fox Glacier, Westland National Park, South Island, New Zealand
Linhof 6x12cm camera, 65mm lens
© Andris Apse/Panoramic Images

LEFT
This scene is predominantly comprised of dark tones. The instinct of a reflected light reading would be to lighten the grass and tree trunks. This would have increased the visible detail but killed the atmosphere of the scene, which was taken early one winter morning near the author's home.

Nick Meers
The Mill Race, Putley Mill, Herefordshire, UK
Hasselblad X-Pan camera
© Nick Meers

Incident light readings

This method is, for the photographer who shoots transparency film, a more reliable way of metering, bar certain reservations. It is based on the idea that you measure the light that is actually falling on, and illuminating, your subject, no matter what density, reflectance or colour it might be. Light meters are equipped with a diffusing dome, or invercone, that can be placed over the light sensor to take the reading. Theoretically, you set up your camera position and make a careful note of the direction your subject is facing, then you amble off in its direction until you reach the same lighting condition that is playing on your subject, turn around 180 degrees and point your light meter exactly at the camera, not the light source. If read correctly, this will give accurate results every time. The basic concept is a good one, but out on location the theory can rapidly fall apart. Consider, for example, setting up on the rim of the Grand Canyon and pointing your camera across it to the other side, several miles away. Are you going over there to check the light? Don't worry, all is not lost. As long as you can simulate

A classic exposure problem: dark rocks and trees and bright water. This was made immediately after a tropical rainstorm and everything seemed to be glistening. I took a reading from the brightest part of the waterfall, then from the darkest shadow area and instead of going for a halfway compromise, I opted for about a third down the scale from the brightest part. Fujichrome Velvia held the shadow detail magnificently.

Nick Meers
Rochester Falls, Mauritius
Hasselblad X-Pan camera, 45mm lens
© Nick Meers

83

the light falling on your subject (even to the extent of creating some shade across your meter), you'll usually be fine if you can turn 180 degrees from your camera position and point your meter behind you. There will be occasions when you might be shooting a bright subject from a shady position, for example, and you will just have to venture out to find an area that has a similar light condition. If it is right next to you, all you have to do is sidestep into the light, and point your meter parallel to where you would be pointing it, if only you were able to get to your subject. It's easier than it sounds and highly effective.

Spot meter readings

These are, in effect, miniaturised reflected readings, with the benefit that you usually have a choice as to how narrow and specific your reading is. They can be highly effective in building up visual information around a scene before you decide on the shutter speed/aperture combination for your camera. Some photographers take many spot readings across a scene and employ the readings from the brightest highlights and the deepest shadows to make a middle-to-bright or middle-to-dark reading according to whatever zone system they prefer, what film type they are shooting, and what type of paper the image might end up being printed on. A different approach to spot meter reading is exemplified by, among others, Mark Segal (see page 116), who is aware not only of having too much information from specific areas, but also of the need to react rapidly to changing light conditions, especially when shooting rotational pans at speed from a helicopter. He uses a spot meter that gives him a precise reading from the most important part of his picture, and to balance it with the bright and dark areas that surround it.

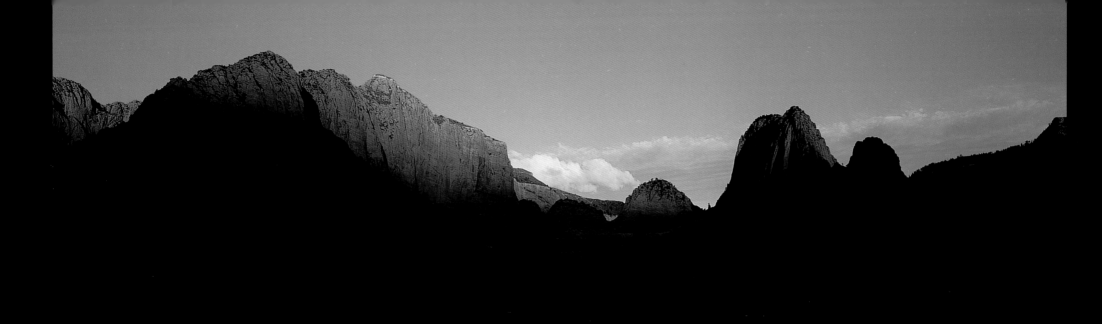

ABOVE

A spot meter reading was taken from the sunlit portion of this mountain range. By applying this reading directly to the camera, I was able to make the rest of the scene fall into deep shadow.

LEFT

It would have been very inconvenient to have had to cross the moat around this castle to take an incident reading. Fortunately, I was able to take a reading from were I stood, which was bathed in similar light. Also very fortunate was the placing of a large tree behind me, which cast a shadow across the far bank. I set up my tripod in the shadow of the tree to avoid the embarrassing "photographer's shadow" problem.

Nick Meers

"The Court of the Patriarchs" at dawn, Zion National Park, Utah, USA

Hasselblad X-Pan camera, 45mm lens

© Nick Meers

Nick Meers

Hever Castle, Kent, UK

Fuji G617 camera, 105mm lens

© Nick Meers

Built-in meters

Meters that are built into most 35mm, and some medium-format, cameras give the photographer the choice of centre-weighted, averaging, spot or automatic multi-zone options. Many medium-format cameras offer a meter built into a detachable prism head, which may be purchased separately. While built-in meters can be very useful in some situations, they can be easily misleading, as they still employ the basic reflective reading method. There is also a potential danger in relying too much on these very clever tools that think for you. If you have one of the few panoramic cameras which does have a built-in meter, make sure you get to know it well and learn when it needs to be overridden.

Filters

Filters can also affect meter readings, especially if they are very dense, or if placed over the lens of a camera with a built-in meter. Each filter has its own exposure factor to adjust for correct exposure. Known as the filter factor, and usually expressed as numbers equivalent to the number of f-stops of light that they are blocking out, this must always be taken into consideration when making your calculations. If you do not know it, simply hold your filter in front of the meter and take a reading through it so that you can set the camera appropriately by either adjusting the shutter speed up or down, or adjusting the aperture. Neutral Density graduated filters are extremely useful for helping to adjust exposure over a brighter part of the photograph without affecting the density of the lighter portion, or the overall colour balance. They are available in different densities to enable precise control of a (measured) area, and of course do not

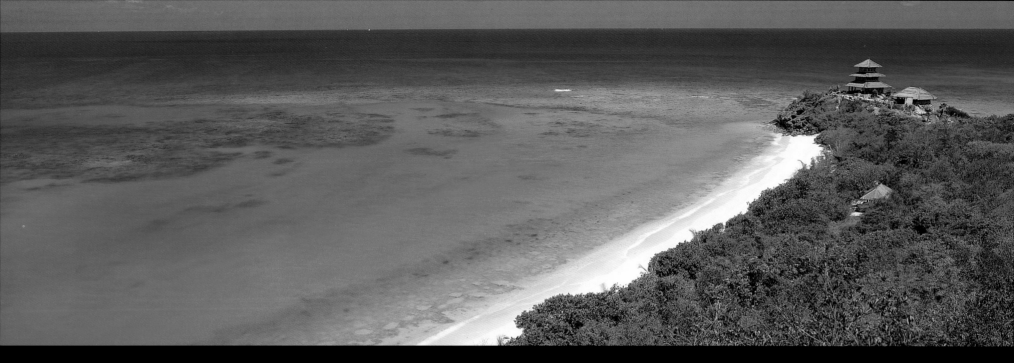

need any exposure compensation provided that the reading is taken from the lighter part of the picture area. They are vital for location photography, as they enable a sky to retain its detail while exposing for the foreground, thus avoiding "whiting out" the sky. Polarising filters affect the waveforms of light from reflective surfaces, and are most often used to lessen the effect of reflections and glare from water or glass. This has the effect of deepening blue skies and saturating colours. The effect alters visibly with rotation of the filter. They are available in two types, circular and linear (a reference to the way they change the light waves, not to their physical shape). SLR cameras with complex autofocus systems require circular type polarisers, whereas manual focus cameras can use either. Polarisers should always be placed in front of any other (polyester) filters fitted to the lens in order to perform correctly.

LEFT
"Another first morning in a new country – I was driving through the amazing countryside and the road ended at the lake's edge where I watched the sunrise, set up the camera and waited."

Mark Segal
New Zealand
Linhof 6x17 Technorama camera with 90mm lens
© Mark Segal

ABOVE
Polarising filters are often used to reduce reflections on the surface of water and thus increase the colour saturation.

Nick Meers
Necker Island, British Virgin Islands, Caribbean
Fuji G 617 camera, 105mm lens with polarising filter
© Nick Meers

panoramic masters: horst hamann

Horst Hamann's first awakening to the panoramic format was a clearly remembered childhood experience, watching the wide-format film of *Dr. Zhivago* as a ten-year old in a cinema in Mannheim, Germany, where he grew up. The format struck him as otherworldly and was to stay in his head and preoccupy his future visual ideas. The work of photographer Josef Sudek also impressed him enormously. Then, years later, in a gallery in Cologne, he was captivated by the black-and-white urban landscape photographs of the architect Klaus Kinold. He bought a print, which took him a year to pay for. Later, he met Kinold in Munich, who told him he used a Linhof Technorama. Horst put an ad in the local paper the following day for one, and eventually bought his own.

Hamann owned his first camera at sixteen years old and was determined to shoot his own panoramas one day. He took various jobs, including work in a sausage factory, to pay for his first 35mm SLR camera, a Minolta. His first serious photographic work was done while walking in Scotland, and through his combined love of music and imagery, he started to produce his own slideshows. He travelled the world with his shows and sold prints of his work in many countries. He never went to art school, but did once attend a photography workshop in Maine with, among others, one of Sudek's assistants from Prague and this inspired him to go further. Horst started taking pictures professionally as soon as he could. He settled in New York in 1989, and spent every extra penny earned from commercial assignments financing some personal projects. The most well-known of these was his acclaimed collection of vertical panoramic shots of the Big Apple, which were published in the international bestselling book *New York Vertical* in 1997. This was followed by *Vertical View* (vertical pans of other locations) and *Horst Hamann New York* (horizontals), both in 2001.

Hamann shoots pans both for business and for pleasure. His preferences for subject matter can be found all over the world, from Iceland to Hong Kong, "wherever there are humans on the planet". Horst is fascinated by what humans do, and is attracted by ironic, slightly surreal, subjects. This doesn't necessarily have to include the people themselves, rather the mess they leave behind, from gas stations to industrial landscapes to vast skyscrapers in New York. It all makes good pictures, and good sense, to him. He is about to embark on a two-year black-and-white project for a German train company, which will allow him the freedom to choose his images as he goes, an enviable position for a photographer. His intended audience is primarily himself, and nowadays he shoots as if it were all personal work. His pictures are also intended for publishing and for gallery walls, so he pays close attention to the quality of his work. Horst shoots other formats also, but his passion remains with the vertical panoramic, and with his favoured camera, the 6x17cm Linhof Technorama, for its quality and resolution. Working without a tripod, he is dependent on 400 ISO black and white negative film, and

is happy with the results from Agfapan and Fuji NeoPan. He printed his own work for more than twenty years, but with the larger prints now needed, he scans them and sends them out to his favourite New York lab, Modern Age, where Lloyd Peterson works his magic. He also has prints made by Jochen Rohner in Berlin, who coincidentally also prints for Klaus Kinold, one of his original inspirations. He has successfully produced thirty-five-feet-long prints from his Technorama negatives, and has digitally produced a New York vertical print that is eight metres high, for the Photokina 2002 show.

While the urban landscape remains the main focus of his work, the new 35mm dual-format Hasselblad X-Pan allows him to include people in his pictures. The new potential of agility, movement, speed and interchangeable lenses allows a looser approach to his photography with this smaller rangefinder camera. He now feels that he can get closer in to include more pictures of people and movement. He likes to keep his shooting absolutely loose. He believes you have to "research the subject as much as possible, then go in and follow your eyes and your instincts, make a picture". He likes to travel light, and only takes his camera and a few rolls of film in a small bag to avoid detection and maintain momentum. He is a great believer in keeping things simple: "Too many people are foiled by technical features, and forget about the importance of the image". Horst doesn't want too many technical options to think about, so he keeps the set-up deliberately simple. He doesn't even use a light meter any more.

Because he always shoots without a tripod, he foregoes the luxury of small apertures, great depth-of-field and long exposures. He nearly always shoots between f16 and f22, and has no need to stop the aperture down further when handholding the camera, as he can confidently shoot speeds right down to a fifteenth of a second, as rangefinder cameras have no mirror. His lenses of choice are the 45mm on the X-Pan and the 90mm on the Linhof. He doesn't even use a centre-spot filter to even up the light, as he would lose an extra stop of exposure speed, so he shoots "straight" and compensates later at the printing stage, if the image needs it.

Hamann never uses filtration, nor does he feel the need to use extra lighting. He likes dull overcast lighting as much as dramatic shadows. Black and white is a very forgiving medium and can retain immense depths of tone, so he likes to print deep blacks and all the grey tones later, in the darkroom. He uses a piece of dark cloth for wrapping around the front of the lens and pushing up against the glass of sealed windows in New York skyscrapers. He doesn't work with any additional gimmicks, and seldom with assistants, except on commercial shoots where the set-up demands it.

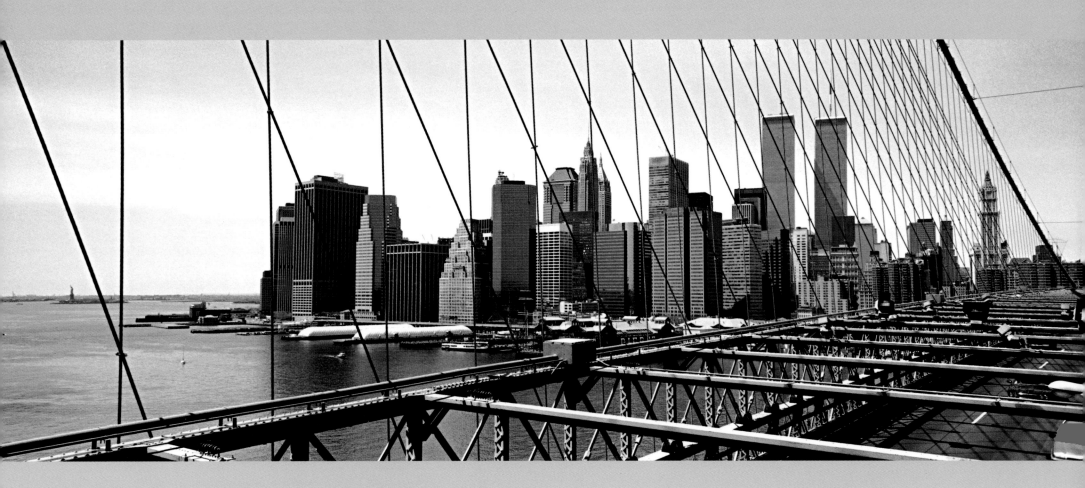

Note how the suspension cables from the bridge serve to create
a sense of movement, leading the eye across the picture plane,
while also serving to frame the image into smaller segments for
the viewer to admire individually.

View of New York City from Brooklyn Bridge, USA
Linhof Technorama 617 camera
© Horst Hamann

This strong abstract shape gains its sense of scale by the
inclusion of human figures, and the balance of the image is
held by the two white triangular lights at the lower right.

Interior view of the Guggenheim Museum, New York, USA
Linhof Technorama 617 camera
© Horst Hamann

91

When questioned if he would like to use any ultimate camera that hasn't yet been invented, Hamann replies that he would ideally like the mix of a Technorama and an X-Pan: 120 film, a more compact camera body and interchangeable lenses.

He is passionate about the 3:1 ratio, and replicating the angle of 98 degrees that human eyes can see, and is not interested in the wide world of 180 degrees and beyond. It is the angle of view that's vital to the perception of his pictures, and he doesn't see an anomaly in placing that "human head vision" on its side to create vertical panoramas. His advice to anyone wanting to know more about panoramic photography is to keep shooting: "Images are all a matter of perception. Panoramic is a great format, the cinema of real life".

93

"At times, in a beautiful place, even being able to record
everything around one is not enough to capture the essence of
the moment. Here, with a slow shutter speed, the Widelux
becomes my dancing partner, celebrating the glory of a summer's

Julia Claxton
Summertime
Widelux camera
© Julia Claxton

movement

Contrary to popular perception, panoramic cameras lend themselves very well to shooting movement, sometimes most unpredictably, reacting in different ways depending on their type. They are most often unwieldy machines, and don't always seem the most convenient or ideal for this type of photography. The key to their suitability is of course in the shape of the format that they shoot, whether it be a shortened ratio of 2:1, or the more popular 3:1, or even longer. Motion blur can be most effective in the panoramic "letterbox" format, which lends itself ideally to moving subjects utilising the extreme width. The different camera types are capable of very different effects due to their obvious physical attributes.

Flatback cameras create motion blur by tracking, or panning along with the subject, while using a slow shutter speed to blur the background. The Linhof Technorama, the Fuji GX617 and most especially the Hasselblad X-Pan are easy cameras to handhold, and if loaded with the right speed of film, may be tracked along with a subject very easily to create great motion effects. Alternatively, the centrally located shutter in flatbacks facilitates the use of flash and high-speed photography, enabling the "freezing" of motion.

Swinglens cameras open up some very different possibilities to shoot movement, especially if one considers the potential offered by a lens that always swings in the same direction, usually left to right. The Widelux and Noblex cameras are cases in point, and if moved while exposing at slow shutter speeds can create extraordinary, sometimes wildly unpredictable, results to great effect. It is possible to achieve a stretched effect if, for example, the lens is moving in the same direction as the subject, and thus renders it wider than the human eye would normally see it. I have, for example, long wanted to make a picture of a horse jumping over a hurdle at the same speed as a lens rotation, to result in a horse-with-stretched-neck effect. If the subject is travelling in the opposite direction to the lens travel, however, the effect is compressed, and, given the right combination of shutter speed and subject speed might even make a moving subject disappear altogether!

Rotational cameras can record movement in yet another way, especially if timed correctly with moving subjects travelling across, or through, their picture plane. Consider Alan Zinn's extraordinary Lookaround vertical-spin panoramas, especially the triptych series, which shows how people have moved while the camera exposed three full rotations. Another variation, if a slow horizontal rotation is made while a subject approaches the camera, and then passes close by to move off in the opposite direction, may result in recording the subject three times in three totally different places on one strip of film, with the background staying the same. This is where we enter a completely different concept of stretching light and time, raw materials that the makers of panoramas have always been privileged to work with.

The success of this image lies in the contrast between the moving subway train and the single figure in the foreground, who remained static during the exposure. The panoramic format provides additional emphasis to the horizontal streaks made by

Horst Hamann
Subway still life, New York, USA
Linhof Technorama 617 camera
© Horst Hamann

TOP LEFT
This picture was shot from the giant underwater viewing area on "dry land" in Europe's largest aquarium, and demonstrates the fun that can be had with such a light and versatile camera. I used tungsten film both to create an otherworldly blue feel to the image, and to neutralise the harsh overhead (yellow) lights above the water. No underwater housing neccessary!

Nick Meers
"Underwater" at the Aquarium, Lisbon, Portugal, 2001
Hasselblad X-Pan camera with Tungsten film
© Nick Meers

BOTTOM, FAR LEFT
The photographer selected a slow shutter speed and panned the camera to follow the movement of the cyclists, taking care to keep the central cyclist (the main focus of the image) in the same position in the frame. As a result, the background has been reduced to a streaky blur.

John Post
Bike race, Manhattan Beach, California, USA
Hasselblad X-Pan camera
© John Post/Panoramic Images

BOTTOM LEFT
I deliberately wanted the movement to show in this picture, made in the rain while moving along the Seine on a Bateau Mouche. For me, it captures the essence of the tourist experience in Paris. This shot would have been very difficult to take without an X-Pan camera, as it is easy to handhold under difficult conditions.

Nick Meers
Eiffel Tower at night, Paris, France
Hasselblad X-Pan, uprated film
© Nick Meers

RIGHT
For this triptych, the Lookaround 360 camera was held off-axis at one end of a tripod. One exposure was made with three continuous 360-degree rotations to make one long uninterrupted image. The print was then cut into three strips which were arranged to show the pedestrians moving through the scene from right to left.

Alan Zinn
Philadelphia Triptych, Philadelphia, Pennsylvania, USA
Lookaround 360 camera
© Alan Zinn

panoramic masters: joe cornish

Joe Cornish is a master technician with outdoor light. His work is unmistakable, and has taken him across the world shooting many travel books and articles. He is particularly well known in Britain for his coastal work for the National Trust and for his stunning landscapes. He works in several formats and does not consider himself a panoramic photographer as such – he feels that the format should suit the subject.

Joe says that his interest in panoramic photography was sparked, initially, by other photographers and painters. His influences are varied, and include Turner, Constable, some seventeenth-century Dutch masters (Jacob van Ruisdale), Gericault, Claude Lorraine, Poussin and of course, the master landscape photographer Ansel Adams. Photographically, he was not influenced by anybody working in the 612 format, as he'd never before seen any work of that shape. He felt he could make 6x12 his own and didn't feel he'd be aping anyone else's style as he explored its boundaries.

Having worked as a travel photographer with a square format for many years, Joe realised that it was time to change direction. He wanted to focus all his energy into landscape photography and in trying to capture those rare, elusive moments of light. Thus it was important to continue working with rollfilm in order to remain rapidly responsive. He realised that 6x12cm (a ratio of 2:1) gave him a dynamic approach to composition and that he could also shoot and react quickly. He feels that panoramas have released him from his square-format shell. He has tried working with 6x17, but doesn't feel the need to move up to a larger or longer format. 6x17 imposes severe limits on Joe's preferred foreground-oriented compositions. He doesn't see the world in such an extended "letterbox" way.

Joe often works with a 4"x5" Ebony SU field camera, with lenses ranging from 58mm to 500mm. With the option of attaching his 6x12 film back, this gives him enormous visual flexibility. But he also carries three Horseman 612 camera bodies, one of them a shift model, equipped with 45mm, 65mm and 90mm lenses, so he's always ready for those fast-changing light conditions. While elusive lighting conditions are still paramount to his work, the majority of his 612s are now in the vertical format, an interesting departure from the normally accepted view of "human vision". Joe's own view of human vision is that we constantly scan around us, taking in a combination of selective and peripheral vision, reading the parts that interest us in any particular situation. Photography is only ever a selection of the subjects within that vision, and therefore the choice of format helps reveal the subject as perceived. He has even thought of shooting a series of circular images, perhaps as a full-field view from 5x4 lenses on a 10"x8" format. Using the softening at the edges to almost replicate human vision, he is intrigued by its possibilities. Joe sees his preoccupation with large foregrounds as analogous to the experience of life as a journey, moving through the landscape. Because any symbolic journey through the landscape starts with an initial step, he is equally interested in what's at his feet as he is in the middle distance, and all the way through to the horizon. He is constantly striving to find a way of interpreting the landscape so that all these elements form a coherent whole. He retains a pragmatic approach to using formats in his landscape work, selecting the right camera/lens/film combination for the image in his mind. His work is therefore not exclusively panoramic, but fascinating nonetheless.

His subject matter shows a preoccupation with natural beauty. Landscapes, coast, mountains, rocks all play their part as iconic symbols in the landscape. He has long had a particular passion for the canyons of Utah and Arizona. The 612 format links disparate elements from sky through to foreground very effectively and he has used it to make a compositional point many times. His images of Bryce Canyon are visual slices of a much larger world. He shoots mainly at dawn and dusk, though sometimes not, as extreme subjects such as canyons must be shot in the middle of the day for the light to penetrate their depths. For close-up images, reflected or soft overcast light is often preferable.

While we all like to think that we arrive at a scene with no particular preconceptions about composition, Joe thinks that this is an inevitable part of personal vision. From a formal viewpoint, he'd rather trust his senses to think laterally around a composition in any situation. Of course we all carry the baggage of past experiences with us. He has a preference for images that contain harmony and depth, both in terms of tension and serenity. He doesn't mind discordant elements in the picture so long as he can make them work together somehow. His innate sense of composition shows in his work. He doesn't profess to using any special accessories, though he suggests, tongue firmly in cheek, that the best accessory you can have is an assistant, to cast a shadow across the lens at the appropriate moment to cut out flare. Flare illustrates a photographic process that is not at all desirable to him – he wants the subject of the picture to be viewed without any reference as to how it was created.

Filtration, therefore, is essential most of the time. Neutral Density graduated filters are vital for even illumination across the film plane. If there's a sky in the composition, he would expect to graduate it, especially if there's a large exposure difference with the foreground. Joe only ever uses filtration to balance a lighting situation enough for the film to read the whole picture evenly. Filtration is used purely to balance light and colour. Another filter that's vital to ensure even illumination across the film plane is a centre spot. This is essential when working with very wide-angle lenses. On the Horseman

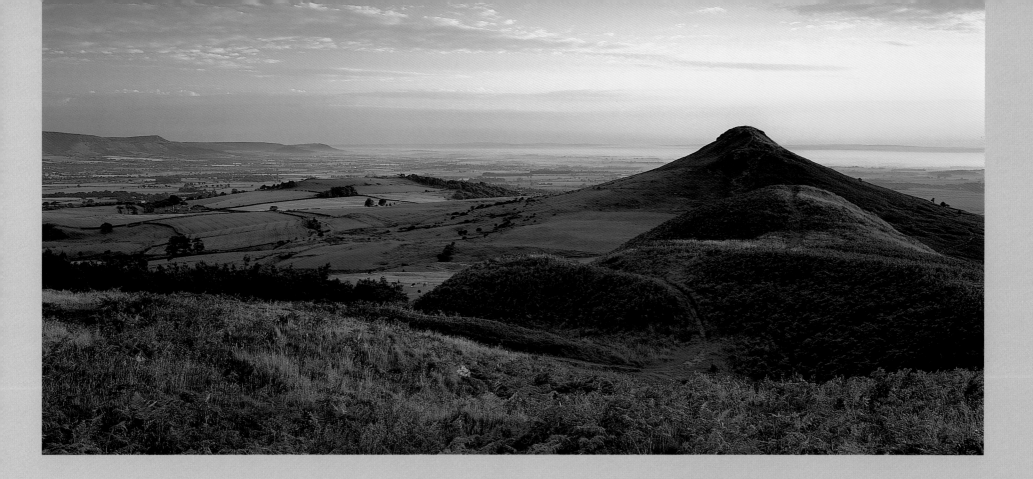

612, the 45mm has a huge coverage across the 6x12 format, almost equivalent to a 14mm lens on 35mm format. Shot without the centre spot, the picture would suffer vignetting, with a light fall-off around the edges approaching two stops. Of course, this is no great problem if shooting negative film, as it can be rectified later in the darkroom, but Joe always shoots on transparency film, namely Fuji Velvia, Provia F and RMS 100/1000 (generally rated at 200) – all for their differing colour palettes. It is absolutely vital, then, that he gets his exposures accurate at the time of shooting, as there can be no going back for a reshoot when dealing with rare light and exotic locations. Additional lighting is not usually used, but he has a pragmatic approach to it. Joe has even used a small flashlight to illuminate seashells in the foreground on a darkening beach, painting with light to great effect.

"The beauty of working 'in your own backyard' is that you get to know the potential of the area better than you ever could when travelling. There are only a few days in the middle of summer when it is possible to shoot this angle on a fine evening and not have the sun shining into the lens. While the timing of this shot was planned accordingly, the inversion haze that covers the distant lowlands was not. Typically with a successful landscape shot, there is an element of luck and good judgement."

Summer Evening, Roseberry Topping. North York Moors, UK
Horseman SW612, 90mm f/6.8 lens, Lee 0.9 ND grad filter
© Joe Cornish

The real limitation of fixed-lens cameras for Joe is their lack of tilt facility, but with untrawide lenses, this is less of a problem due to their immense depth of field. When asked about his ultimate camera, one that perhaps hasn't yet been invented, he thinks that built-in filters would be useful, perhaps in a rotating turret behind the lens. The Horseman is highly portable, but difficult to shoot rapidly due to its safety catches, so a version with a self-cocking shutter mechanism (and motor drive!) would be invaluable for catching those fleeting moments of special light. Although the X-Pan is designed to cope with these situations, its format is just too small for Joe. The 6x12cm format covers almost four times the area of a 35mm, so there is really no comparison for him when it comes to superior image quality. Quality is king for Joe, and it shows.

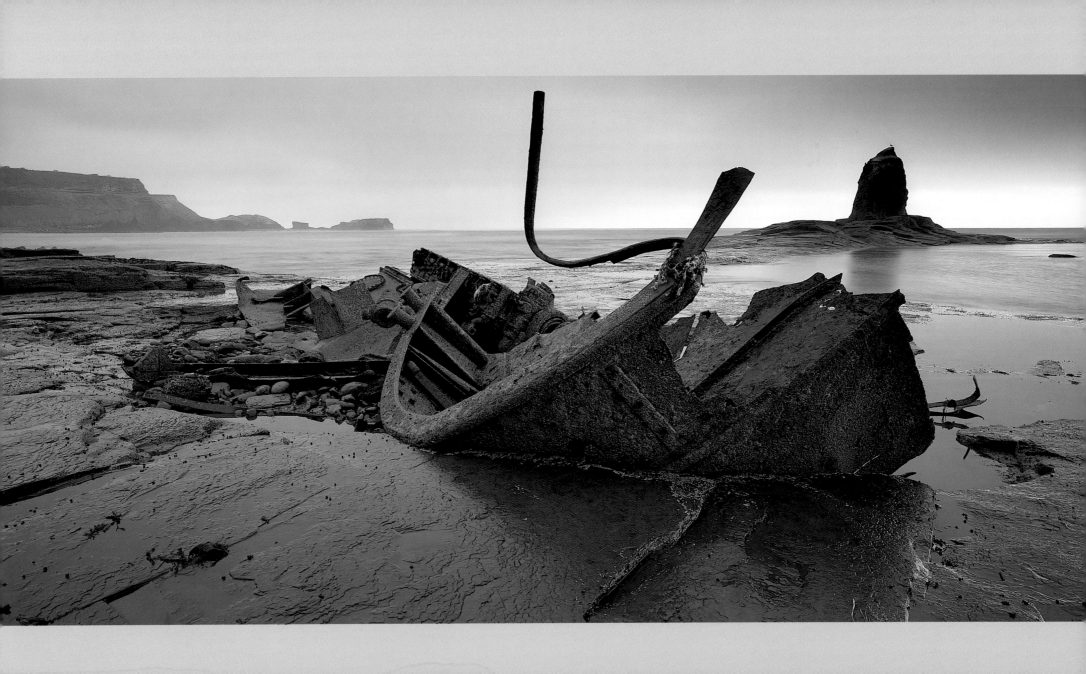

panoramic masters: karen kuehn

Karen Kuehn grew up a free spirit in California in a large family. She lived an outdoor lifestyle and regularly camped, fished, waterskied, dirt-biked and went to the beach. She had occasional access to a Nikon, and even enrolled in a class to learn more. She thought she would grow up to be a veterinarian, and had a healthy Californian disdain for a straight and narrow lifestyle. She only took a few photo classes for fun. "Next thing I knew, I was the freak in the class spewing out a multitude of ideas. I wasn't very good with the technical stuff at first, as matter of fact, I was a bonehead. But there was no shortage of ideas. I did the array of photo classes and graduated".

She was encouraged to go to her local College of Design, where she submitted a zone system-style portfolio and gained an advanced placement. Having worked a few seasons as a National Park ranger, she returned to Yosemite to gather her thoughts and escape the fast pace of education. She went back to the Art Center for a few more terms, won a scholarship and graduated top of her class, the only child of her family who went on to higher schooling.

After graduation she was lucky enough to gain an internship at *National Geographic*. Her first assignment was shooting mountain men near Mt. Kennedy with the first American to climb Mount Everest. Her work got noticed, and eventually she headed for the Big Apple with little money and a hunger to shoot pictures, and set about visiting as many magazine editors and art directors as she could. Karen was twenty-six when she started shooting stories for *New York Magazine*, *Travel & Leisure*, *New Look*, *Interview*, the *New York Times* magazine and many others. Two years later she was shooting stories for *Spy* magazine, and wanted to shoot wider, as she couldn't fit everything in with the 20mm lens of her 35mm camera. She rented her first panoramic camera, a Widelux F7, and instantly liked what it could do: she used it more and more, and then ended up buying it. She worked on the *Saturday Night Live* TV show for a season, did a number of travelling assignments and has been shooting both editorial and advertising assignments ever since, using the Widelux whenever appropriate.

Her earliest influences were drawn from Renaissance paintings and Baroque triptychs, images that reveal their subjects in sumptuous surroundings. She loves to "shoot wide", incorporating the surroundings and backgrounds in her work, leading the eye into her pictures through judicious placing of foregrounds. She learned about the black-and-white zone system early, and owes a lot to the masters of landscape photography for her early inspiration. Many panoramic photographers seem to slow down with their large cameras, but she likes to shoot fast and loose, keeping moving to gain the unexpected in her images. For years she shot backstage pictures at music concerts, and the Widelux enabled her

to place her subjects within their environments. Karen likes to shoot with all kinds of cameras, both commercially and for herself. She likes to have fun when out shooting, and finds the Widelux, and now the X-Pan, natural cameras to fit the hand. She'll shoot with anything that's appropriate, from large format 20"x24" studio cameras, to Hasselblads, to the 6x8cm Fuji and toy cameras, and even makes her own lenses. "Every project is its own animal" she says, and develops her ideas from the visual demands of the job. The ideas come first, and the format follows on to express those ideas. When asked if she has any particular preferences for suitable subjects, she laughs, and replies that projects come and go too fast: "Right now I'm working on a self-portrait project, after that a project on the elderly, then a spiritual project, then eventually I'm going to die. Then maybe I'll have touched somebody's life through the power of photography".

Karen recently moved from New York to New Mexico, taking her vibrancy with her. She describes it as living in the land of enchantment. She likes to shoot anything and everything, using her senses to live her life to the full. Photography has enabled her to live with a happy heart, with thanks to all the editors who gave her jobs along the way. She tries not to set out with any preconceptions about composition; she is more interested in telling visual stories as they happen. There is no set formula for her when shooting pans, except to always check the importance of the foreground, whether the format is vertical or horizontal. "The most important thing must be in the foreground. With wide-angle shooting, you tell your story with the main part of your story lined up first. The panoramic format allows you to also incorporate the environment, so it is possible to include everything around the subject too." Her advice is to be athletic, shoot wide, shoot tight, use your senses, work on the emotional impact, think about the feeling that you want to evoke, and how it would smell or taste. Although the lighting is very important too, the feeling in a photograph is made up of many ingredients, and, like cooking, those ingredients are all essential.

Karen's special requirements for a shoot are not too extravagant: a small Domke bag to throw her cameras into, tons of film and a flexible reflector. And being left alone to think about her pictures. Her way of dealing with exposure across such a wide area is to try to shoot in the right light if possible. There will, however, always be times when you have to shoot in the middle of the day, at the sun's highest point, so she ensures even light balance through a variety of methods: fill-in flash, huge reflectors and shooting her subjects in the shade. She's even used infrared film when faced with "too-hard light", an interesting solution to unwelcome light.

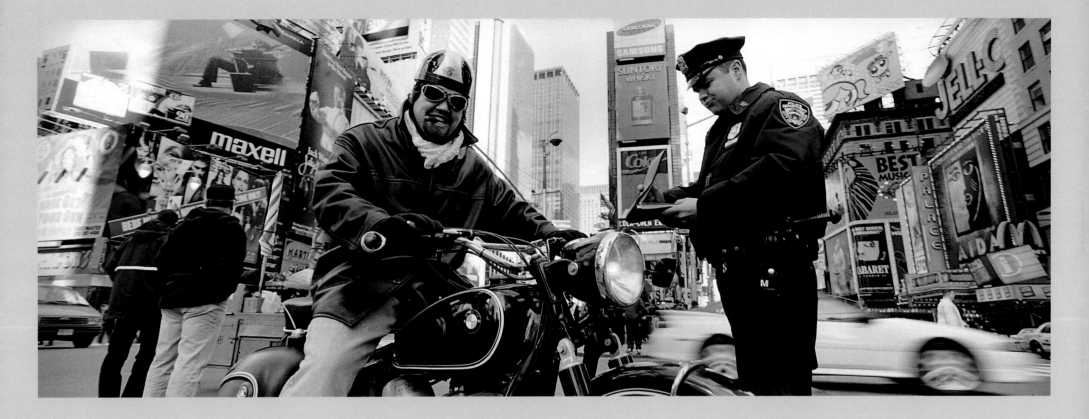

Bike rider and cop 105
(Kevin Thomasson, photographer, in Times Square, New York, USA)
Hasselblad X-Pan camera
© Karen Kuehn

106 Jesse James
 (bike builder and CEO of West Coast Choppers, California, USA)
 Hasselblad X-Pan camera
 © Karen Kuehn

Karen is no stranger to filtration and uses Wratten filters wherever needed. She pays particular attention to the effects of warming and cooling filters, and uses them often. When shooting in black and white, she often uses orange or red filters for mood effects. She uses extra lighting "all the time." With panoramics, though, she tries to keep it simple. When shooting with the Widelux, she uses (constant) tungsten "hot" lights, to match the moving lens. With the X-Pan, she often uses fill-in flash, though when shooting black and white she prefers overcast light, so that she can meter using the zone system.

One of the best things that ever happened to her while shooting pans was at a concert at the Webster Hall in New York some years back; the Chili Peppers and Motorhead were playing, and Joey Ramone, covered in hair down to his nose, walked up to her and asked her to take his picture. She set the Widelux to a fifteenth of a second, and as the lens rolled slowly across, his smile just grew and grew and blurred the shot. He was so intrigued by the Widelux and its moving lens that he couldn't keep still, but Karen's "shot that got away" was a priceless moment, a smile she has never forgotten.

Surfboys in the snow
(film director Steven Schmidt with drummer Clem Herbert,
Wall Street, New York, USA)
Widelux camera
© Karen Kuehn

107

Karen Kuehn is a photographer who defies categorisation; her work and interests are full of variety. She claims an artist's heart, loves life, and is well respected for it. Her life is her art. Although she's moved out to the country, she still loves her New York clients, as her work enables her to persist with her visual curiosity. "Photography has given me a silent licence to move in and out of many circles of life. I am grateful for this privilege and consider myself blessed. Taking a picture doesn't mean stealing a soul if the subject allows it, a kind eye can reveal much emotion without sacrificing anyone's integrity."

FAR LEFT
Ali Rogers and the Flatiron building, New York, USA
Hasselblad X-Pan camera
© Karen Kuehn

LEFT
Surf Angels
David and Heather at Unsound Surf, New York, USA.
Widelux camera, shot on InfraRed film.
© Karen Kuehn

Californian musicians Red Cross
Widelux Camera
© Karen Kuehn

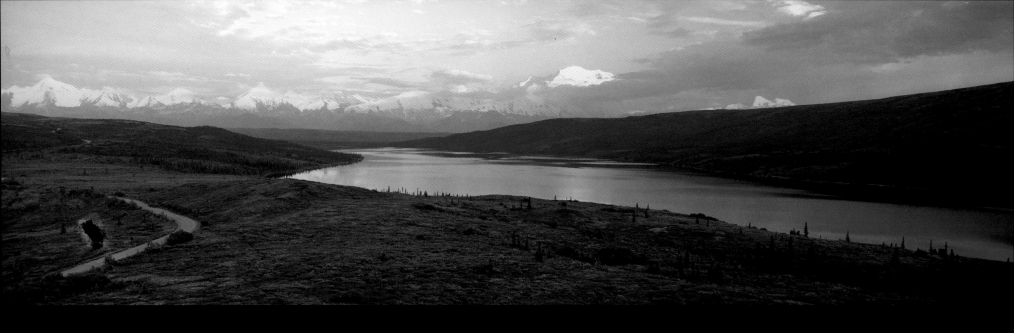

110

One can never be too careful with shooting pictures on location, no matter how well prepared you might be: "I made this image while in Denali National Park, in Alaska. Our group was at Wonder Lake near Ansel Adams Point. The mosquitos were swarming all around us, but with the requisite use of head nets, we were able to take our time and compose photos of the beautiful scenery around us, including the Alaska Range with the north face of Mount McKinley, as shown here. Not until I got this roll of film back from the lab, did I realise that a mosquito had flown into the camera back while I loaded it, and was subsequently embalmed into the emulsion of the film during the processing."

Tom Curley
Denali Bug with Wonder Lake, Alaska
Fuji GX617 camera, 180mm lens, Fujichrome Velvia film
© Tom Curley

So you've gone to the ends of the earth to shoot that sunrise? Now what are you going to do with it? We'll assume here that you've already made your choice about whether to shoot transparency or negative film, and hopefully you'll have made the right calculations about exposure to get that latent image onto your emulsion.

Processing

The first stage is to process the film, or "put it through the soup" as we sometimes describe the process. Most photo labs can cope with the panoramic format, from APS to 35mm, and up to 120 or 220 film sizes. The most important thing is to let the lab know that you have shot panoramic frames on the film and make sure they know not to cut your film: clearly label your valuable treasure with a DO NOT CUT warning. You will get it back rolled up in a small tube or box, and it will then be easier to assimilate your results on a light box and judge which frame is the best exposure. Very large format film from Cirkuts and other cameras carry particular problems of their own, and can involve pushing and pulling the film through rollers by hand with several willing assistants. It should be processed by a specialist lab, or with specialist equipment, and there are many enthusiasts out there who can give you advice.

Printing

To get a decent-looking print from a panoramic camera is, of course, a whole other science. Usually there is an issue about getting even exposure across such a wide (or long) area, and if you have shot on transparency film the exposure is much more critical in attaining a well-exposed result. When printing from transparencies there are fewer choices of paper. Most labs offer R-Type (for reversal process) paper such as Fujicolor Crystal Archive to get excellent results. Another archival solution is to print onto Cibachrome or Ilfochrome paper, which gives astonishingly good colour rendition, and should not fade in sunlight. Printing from negatives offers many more choices, but in my opinion, less stunning results. The first step is to establish whether your photo lab is capable of printing from panoramic negatives. Most of the smaller formats can be catered for, as APS and 35mm "cropped" panoramics will fit into most high-street enlargers. Slightly larger formats need to be printed from a 6x6cm enlarger head, with the carrier masked down. The larger film formats need bigger enlarger heads, and here you are entering specialist territory. Negatives from a 6x12cm camera may be printed on a 4"x5" enlarger, while 6x17cm negs need a 5"x7" or 8"x10" head, with the film area masked down. The enlarger head may be swivelled around in the darkroom, and projected onto the wall or the floor in order to achieve the desired size of print.

printed with specialised enlargers that not only roll the film slowly along through the enlarger head, but also wind a roll of printing paper along the baseboard in the opposite direction. This is the same principle as the mechanism involved in rotational cameras, as they wind both film and paper past a slit of projected light.

When you want to print from very large format Cirkut – and other – negatives (up to sixteen inches wide and eight feet long), you are entering the realm of the giant contact print, so-called because the negative is held in contact with the printing paper underneath it, usually by glass. This is also a specialised business, as not only must you be able to produce a giant, even light source (usually a soft box or two from a studio lighting set-up) to cover the entire length of the negative in one exposure, but you must also have the facilities to process the resultant vast piece of paper. These prints have the most fantastic quality, though, as they retain all the details of the original without the drawback of being printed second-generation through an enlarging lens. If you ever get the chance to get close to one, examine it very closely, and you will be astonished by the detail.

Of course, there are many enthusiasts who prefer to print their images in their own darkrooms, and black and white darkrooms are relatively inexpensive to set up and run. The most important requirement is the space to print panoramas, and an enlarger head and lens combination that will have the covering power to deal with your negatives. There is a huge variety of printing techniques, and it is a vast subject already covered in many specialist publications. Panoramic photographs have appeared to great effect in many guises, and the enthusiast is encouraged to seek out the differences between fibre-based, resin-coated, Silver Halide, Gum Bichromate, Platinum, Platinum Palladium, Salt, Kallitype and Cyanotype printing techniques for quality fine art prints.

Digital processing

The "Digital Darkroom" is the most recent method of reproducing photographs. Scanning the originals into a computer, adjusting the image, then outputting to an inkjet, or the more permanent Iris print, can sometimes produce spectacular results. Computers are also able to combine many separate digital images together to make panoramas, with the aid of "stitching" software and image editing programmes. Some of these can be downloaded from the internet relatively inexpensively. They all work along the same lines, namely that you select your photos and click a button, and the software aligns, crops and smoothes the edges of the images to create a ready-made panorama.

Assessing and filing

Assess your transparencies using a consistent 5500K light source such as a daylight balanced light box, not a tungsten-balanced light bulb, as it will give an inaccurate rendition of the colour. Use a magnifier or loupe to closely examine details such as sharpness, depth of field and subject movement. Having removed the frames that you are not happy with, file the rest in archival storage sheets (preferably hanging files that can be stored safely in a lockable filing cabinet). The best images you should scan or take prints of, before mounting them in stiff black card mounts with proper copyright labels and captions.

This near-impossible shot had to be manipulated by computer to erase the enormous hexagonal sunspots caused by refraction inside the wide-angle lens. A lens shade would have been pointless in this situation, so any refraction can be guessed by viewing through the ground-glass screen at the film plane and moving the camera very slightly to minimise the effect.

Nick Meers

Cuckmere River, near Seaford, Sussex, UK

Fuji G617 camera, 105mm lens

© Nick Meers

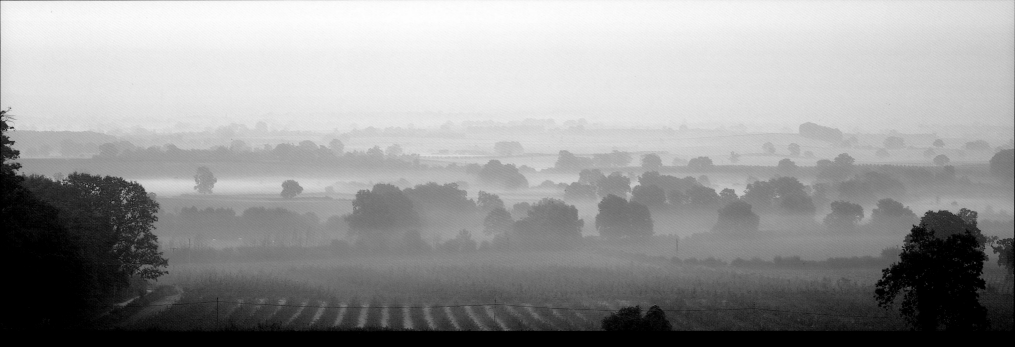

Projecting panoramic transparencies

It is difficult (and potentially expensive) to project panoramic transparencies from all but the smallest film formats. Unless they are masked-down 35mm originals, they require medium format projectors. There are one or two 6x7cm projectors around, which offer the width to project 35mm Widelux, Horizon and X-Pan transparencies, and it is possible to buy pan slide mounts for these sizes, made by GePe and Weiss. For the larger formats, there are such things as 4"x5" projectors, through which it is possible to project 6x12cm transparencies, though I have never seen such a rare contraption. Even more exotic are the handmade one-off projectors for 6x17cm.

This early-morning view was shot after a number of false starts. Getting up at 5am in darkness, one never knows until the light arrives whether it has been a worthwhile visit. On this occasion, as the mist rolled back to reveal the pattern of apple trees disappearing to infinity, I knew it had been worth it.

Nick Meers
Putley, Herefordshire, UK
Fuji G617 camera, 105mm lens
© Nick Meers

This picture was shot to illustrate a story about flower growers
in Lincolnshire, where they allegedly grow more tulips than in the
Netherlands. I filled the frame with an abstract block of colour to

Nick Meers

Field of Tulips near Spalding, Lincolnshire, UK

Fuji G617 camera, 105mm lens

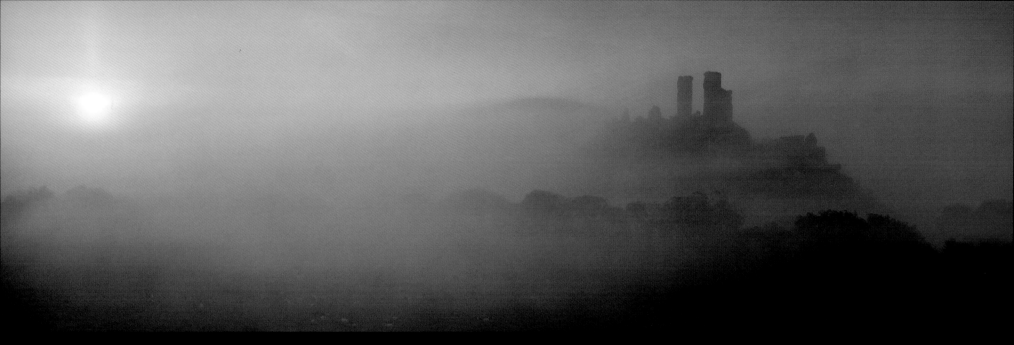

"I've had this shot on my wish list for several years. It involved an outrageously early start. Exposing for backlit mist is difficult, particularly on a panoramic, as there's such a range of tones from the area by the rising sun. I spot metered from mid-tone in the middle. As the sun popped over the horizon, the amount of mist actually increased before the heat of the sun started to burn it off."

David Noton
Corfe Castle at Dawn, Dorset, UK
Fuji GX617, 90mm lens, Velvia with 0.9ND filter
© David Noton

panoramic masters: mark segal

Mark Segal grew up around cameras; his father ran a group portrait business, shooting with Cirkut cameras in the Chicago area for over fifty years. He messed around with a Nikon 35mm camera as a boy, but was just as familiar with a 10" Cirkut camera by the time he was fifteen years old. From the start, he was intrigued by the idea that a panoramic photograph could capture more in the frame than other formats could, and has explored those boundaries ever since. In his earliest experiments, he recalls shooting panoramic images of "cemeteries and bridges and weird stuff and parties and moving people", and he had his first exhibition of images in 1976, aged twenty, in Washington DC. He later bought his own Widelux, and continued to shoot whatever interested him.

Mark went to architectural school, where he gained a degree in civil engineering. After graduation, he worked in engineering as a project manager in the Chicago Metro system. But he had always loved photography, so after four years he decided to quit engineering to try to make a go of his passion. He started in 1982 by selling Cirkut prints and shooting interiors, architecture, amusement parks, and whatever else seemed to be appropriate to the format. He continued to shoot group pictures for about three years to subsidise his other work, selling his prints. About a year later, Mark purchased a Hulcherama 360-degree camera, then a Linhof Technorama, which he continued to shoot with for the following ten years.

He wanted to do photography that involved travelling, so he looked for subjects suitable for the panoramic format. He shot pictures in Europe, and then travelled further afield to Asia and South America. At first, Mark encountered problems promoting his work, as clients weren't sure how to handle the format. Nevertheless, he persisted in trying to win work from architects, interior designers and advertising agencies that held large corporate accounts. In 1992, he set off to New York with an enormous portfolio filled with giant Cirkut prints and panoramas of architectural cityscapes, abstract verticals, full blocks of real estate, living rooms, amusement parks and scenic travel images, and lugged it round to show to sixty art directors in ten days. The move paid off. He was asked to shoot advertising campaigns for several corporate clients including Samsung, McDonalds, Hilton Hotels and won a large campaign for South African airways, which took him around the world.

Mark continued to shoot scenics, and learnt that to get the right commercially useful picture it was sometimes essential to return to a scene over and over until the light was absolutely right, something he feels that many photographers don't pay enough attention to. In 1988, he worked out how to shoot a 360-degree panoramic on 70mm film from a helicopter, a delicate operation involving gyroscopes, gimbals and pieces of scaffold. He took a serious financial gamble and started renting

a camera, then bought and modified an early Roundshot 70 camera with a 65mm lens. After many experiments, his Skypan enterprise was launched shooting aerial panoramics. Also in that year, he persuaded his brother Doug to put away his saxophone and together they started the Panoramic Stock Agency, now known simply as Panoramic Images. In addition to selling images from the picture library, they investigated different ways of marketing posters, postcards and all things panoramic. Then, in 1991, they teamed up with the Japanese Mon Trésor picture agency, forming a partnership to market each other's work across the world, and things really took off.

Segal's work is more commercially oriented than most art photographers and his panoramas have been published all over the world, but because the work is bought through the stock agency, the end-use is usually beyond his control. His preferences for format have been loyal to 6x17cm and 6x12cm for many years. He is currently attracted to the smaller formats, though he still likes to work with the ratios of 3:1 and 2:1. He finds the 35mm X-Pan very versatile, and shoots much more personal work with it. He loves its immediacy and uses it to shoot subjects that can't be shot in any other way. He reckons that about ninety per cent of his X-Pan pictures are shot using the 45mm lens, without the need for a centre-spot filter. The 2:1 ratio gives him more room to crop images later, and he loves the "handholdable swiftness" of the Noblex 150 6x12cm camera. He prefers to use rotational panoramics for making formal visual records, though, and the X-Pan has become his camera of choice because it is more immediate and he can shoot on impulse.

When asked if he has any preferences for subjects, Mark replies that it's been changing recently: "Nowadays I'm doing mostly candid shots of people in their environments, seniors through to kids, working, playing, doing all kinds of activities. I like to catch the interplay of people within a scene. I'm taking more pictures 'of the moment', which have three-way possibilities; these shots have potential for stock, for advertising shoots that look looser and more creative, and for personal work." On the subject of composition, and whether he ever sets out with any preconceptions for a shoot, he is open to what he might find. He might already have an idea for something he wants to shoot, but then finds something else along the way. "Expect the unexpected. Work around a composition, be open to whatever arises along the way, cover all corners". He doesn't research his subjects too much in advance, as planning in meticulous detail is not his way. He prefers to find what he wants to shoot when he gets there.

Mark has a top tip on how to gain correct exposures across such a wide area. Many photographers worry about their zones and areas of light and shade, and balancing up the difference. If you're

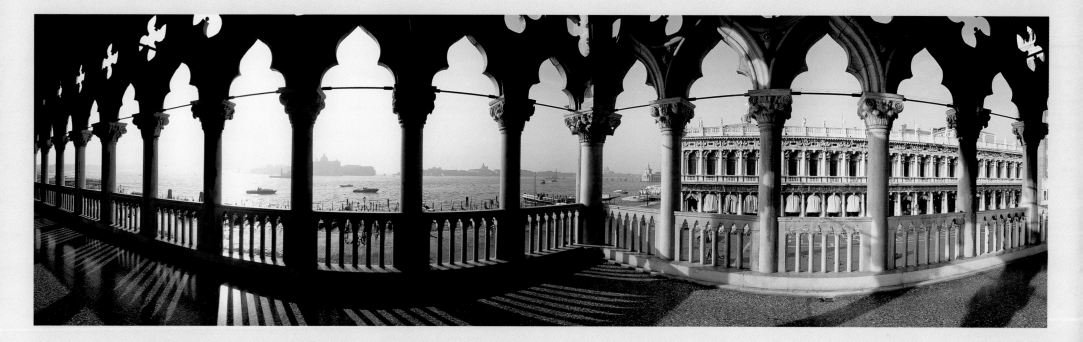

shooting rapidly however the luxury of standing around doing equations is often not possible. "I point my Pentax Spotmeter at the most important part of the subject, expose for the area that's most important, and to hell with everything else – within reason". If the lighting is harsh, he might use a bit of filtration, either with warming or cooling filters. He used to tape filters to the front of his Linhof Technorama, but "it's a lot of bother when you're shooting action. It's also not easy to use graduated filters, especially with the X-Pan, so nowadays I don't bother much". Lighting is a very different proposition, as flash can only be synchronised with flatback cameras. With rotational cameras the lighting must be constant. Does he use it? "Oh yes, I use outdoors for portraits, and indoors, I often use miniature 'hot' (continuous) lights. Recently, I took over 50 hot lights, three assistants and several hours to light the House of Blues foundation room".

Mark's answer to my "any special accessories to help you?" question, brings an interesting response; "I always carries Saltines (crackers) in my camera bag – I spread them around to get the birds either into or out of my pictures when there's an otherwise boring shot."

117

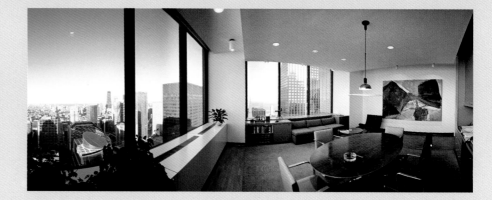

I asked him if there was a special kind of camera that he would like, which hasn't yet been invented. He replied that he used to want a rotating lens camera, and now that he owns many, he's very envious of the highly developed and much faster lenses used in the motion picture business. "Superwide with speed". He thinks that f1 lenses would give him "the opportunity to do more, to work without tripods and have the speed to use filters without affecting the speed of the picture. It would be possible to shoot rotational pans much quicker too". Mark thinks that digital photography has great potential, but doesn't yet have the speed to shoot high quality on location. His ideal fantasy camera would be "a small digital panoramic X-Pan camera, with either a fixed or a curved film plane (like the Noblex) capable of making 100Mb files, that would also fit in a pocket". Here's hoping…

Mark has many anecdotes to tell about shooting panoramics around the world. He confesses to having experienced some very scary helicopter situations, amongst others. "I almost got shot and killed on a beach while shooting stock shot pans in Rio once. People started to throw enormous and dangerous things at me, I had to leave. The very next day on my way up the hill to photograph the famous Christ statue, we drove past a group of men with guns, and as we approached, the men started firing at us. My driver put his foot down, and drove right through them, and I realised my equipment was in the back of the car. It survived, and so did I".

Mark enjoys challenging assignments. His latest projects include shooting aerial 360-degree panoramics with a newly-developed remote-controlled helicopter. Due to security scares in American cities following the attacks of September 11th 2001, it has now become impossible to shoot from normal helicopters and planes, so he has developed a system that can simultaneously shoot video, still pictures on 35mm and 360-degree pans with his new Roundshot 220 camera. The main problem is in maintaining a level horizon, but he remains optimistic that he'll achieve his goals. However, Mark has concerns about the future of commissioned photography. "The big production budgets have gone and affordable advertising shoots are achieved by melting stock shots with computers in the studio." He sees photography turning more and more towards digital production, closing down the expensive advertising shoots that used to give him his experiences. He doesn't see any threat to conventional film shot in panoramic formats for the time being, "until the curved wide chip is invented". He remains totally committed and retains his passion to take on more.

"The assignment was to show an E.R. hospital entrance with energy. Since the camera was rotating at a medium speed, I had to experiment with moving the gurnee fast (for blurred effect), then slow (to not lose detail). It took four rolls and 20 takes!"

E.R., USA, 1991
Hulcherama camera with 35mm lens on 120 film
© Mark Segal

"The brief here was to create an image that captured both the inside and the outside of this place in order to quickly lease the new building. The image required substantial exposure change as the camera was moving."

Downtown Chicago executive office, USA, 1990
Hulcherama camera with 35mm lens
© Mark Segal

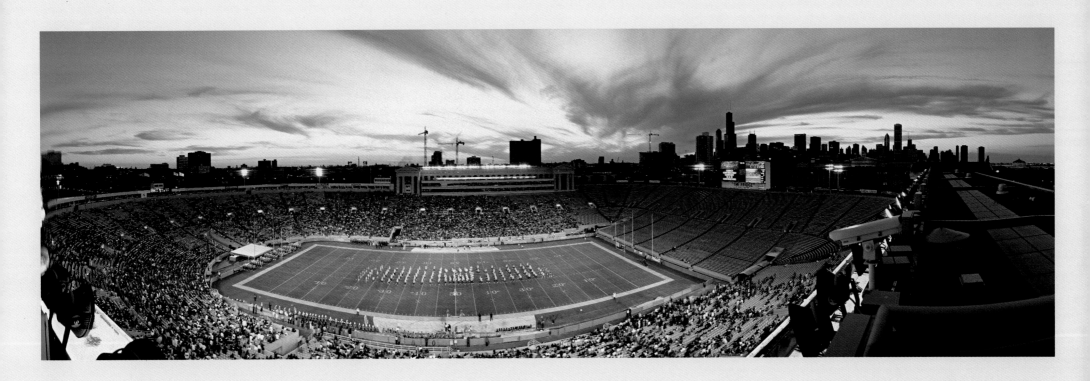

"This was shot during a college football game when the ambient
skylight was low enough to match the inside stadium light. The
assignment was to show the view from proposed skybox spaces
to be built and sold to corporate customers."

Chicago Bears stadium, USA, 1990
Hulcherama camera with 50mm lens
© Mark Segal

121

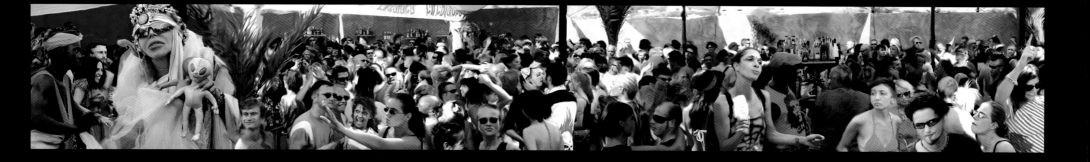

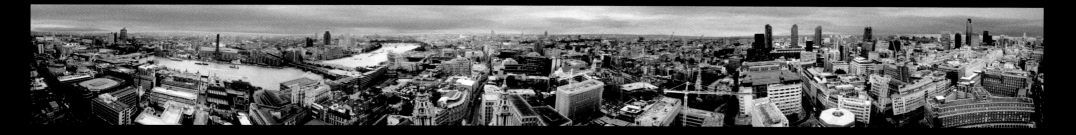

TOP
Henry Reichhold
Early morning rave in the heart of Ibiza countryside, Spain
HP 715 compact 3.3 mp camera (image made up of eighty separate images
and pasted together using Adobe Photoshop)
© Henry Reichhold

BOTTOM
Henry Reichhold
London from the top of St Paul's Cathedral, UK
Kodak disposable camera (360-degree image made up of twenty-four
separate images)
© Henry Reichhold

The easy availability of digital technology has brought hitherto complicated procedures right into our studios and homes, and with it, the ability to create wholly convincing imagery that has never been possible before. Its realism is even seen as a threat to those who have always believed a photograph must represent a "true" visual likeness, and who feel that tampering is in some way undermining the concept of truth in a photograph. This new technology introduces doubt into photography, and makes us wonder if the image we are viewing was ever recorded by a lens, and if it did, in fact, ever exist at all. We must now question our assumption that photographs are realistic visual renditions of life.

The digital darkroom has only just arrived, and is here to stay, and as such is capable of exciting and frightening us all with its potential. Consider that it is entirely possible to create an image made up from one tiny pixel of colour, duplicated, changed, reformed, repeated and rearranged to form a coherent whole picture, and our entire concept of photography as capturing light and form to create an image through a lens must be completely reconsidered. Not so strange, then, are the cries for digitally manipulated photographs to be identified as such when used in the public domain, for fear of upsetting those who still believe that if it's a photograph it must also be "true". As I write this in 2002, I can safely say that digitally enhanced photographs have already been published in our national newspapers and magazines for years, and they're getting harder to spot every day.

Into this new era of the digital darkroom (or "lightroom", if you prefer), comes a different way of creating panoramas. There are principally two types of digital panoramas: Linear images, also known as "extended imagery", describe perhaps more accurately their form and function, which usually comprise a series of stitched images. The other is the all-encompassing Virtual Reality image which is a record of all that is around the viewer. Digital linear images are most commonly made up of a series of images, combined by computer using "stitching" software that hides the joins, and is the twenty-first century equivalent of the "joiners" created by the earliest panoramic pioneers in photography, who had to make do with scissors and glue. A more recent pioneer is Michael Westmoreland, (see separate article) who initially broke new ground in the 1970s with the marriage of Edwardian Cirkut cameras to modern lenses and large rolls of colour aerofilm. He set about recording hitherto unphotographable totalities, such as entire arcades, markets and streets, sometimes skilfully combining images taken from near and far his subject matter. He has used this technique to document a variety of environments in many worldwide locations. Recent advances in inkjet printing technology, with its prospect of stable and semi-archival media, mean that it is now possible to exhibit and sell prints of these hitherto-unseen subjects, theoretically putting these images within everyone's reach.

Stitching software can be found very easily on the internet and there are many programmes available. Perhaps the best way to find out which is right for you is to visit some websites and download trial versions, which are usually fully functioning programmes that expire after thirty days or so. Among the most popular are currently PanaVue Image Assembler, PhotoVista, Picture Publisher, Panorama Factory and Realviz Stitcher, though there are plenty more. The most commonly used general image-editing programme is the highly popular Adobe Photoshop, which no self-respecting computer should be without. For those who do not have access to a computer, there are several photo labs that offer stitching services in-house, such as Panoramics Northwest and Big Photo Help, both based in the United States (see contacts listing at the back for their web addresses).

Another practitioner of the art of stitching, with a totally different approach, is Henry Reichhold, who calls himself a digital pictorialist. His panoramic-shaped images are made up from many different individual images, sometimes hundreds, all shot on a pocket-sized compact digital camera. He combines the pictures by computer, sometimes taking weeks to assemble the images shot in just one session. He usually starts with the background area, then builds the image layer by layer, paying great attention to the scale of the figures. Rather than plan the images out in advance, he prefers to find sections that go together well, combining and blurring and fitting them all together as he progresses. When he's achieved his desired result, he prints the finished pictures out on a sixty-inch-wide inkjet printer. He deliberately makes images with a raw and "edgy" feel to them, preferring the energy that they seem to retain. From making pictures of the English National Ballet to travelling all over Europe shooting the nightclubbing scene, Reichhold is keen to push new boundaries to their limits. He likes to see the structure of his pictures and is not bothered if the grain is clearly visible. He finds that non-photographers do not seem unduly bothered by "seeing the pixels". He is currently working on a project to shoot the world's longest inkjet panorama, to adorn the perimeter fencing of music festival sites, and thinks he knows how he can achieve it. Reichhold's panoramas may consist of many low-resolution digitally stitched images, but they still work as panoramas, perhaps showing us a way into the future of linear extended imagery.

The other, more complex version of digital panoramic imagery is known as Quick Time Virtual Reality, or QTVR, which takes panoramic imagery further still into a digital "cyber-sphere" that only exists in a machine as a series of digital codes, but which can also simulate a convincing all-encompassing picture when viewed on a computer screen or through special eyeglasses.

QTVR is most easily captured by all-seeing digital cameras such as the Spheron or the Eyescan to create fully rotational panoramics that work in all directions, including above and below. These cameras can be used for taking seamless 360-degree panoramic pictures of landscapes, architecture and industry for advertising and e-commerce, with no stitching needed at all. The imagery may also be collected and combined (much more painstakingly) from many images taken with a digital camera, provided that they overlap and combine with each other so that a computer can stitch them together easily. However they are captured, QTVR files are viewed on a computer screen as though looking through a window. The viewer interacts with the image by using the mouse or pressing the computer's direction keys to move around inside the image. A further leap of the imagination is possible when the viewer "hovers" at a particular place in the image, and a visual "hot spot" appears. When this is clicked on, the viewer is instantly transported visually to that hot spot, from where a new viewing position exists. In this way, for instance, it is possible to view

a panorama of an interior from every corner of the room, switching viewing positions with a click of the computer's mouse.

Virtual reality panoramas have been around for a while, and have been taken up by, among others, travel and estate agents wishing to show us their goods on websites in order to encourage business. It is a seductive idea to be able to view your potential honeymoon suite on the other side of the world, from the comfort of your home. One can take "virtual" tours around museums, battleships, hotels and other people's houses, looking all around the rooms, even their ceilings and floors, in a fascinating all-encompassing virtual visual spectacle. Mostly the imagery is still crude, as the operators learn to compose their virtual pictures better (are they, incidentally, still to be known as photographers, or panoramicists, or virtual operators, or virtual tour operators?). Knowing how to compose a panoramic image across 150, 180 or 360 degrees is a skill that doesn't always translate to 360 degrees-and-

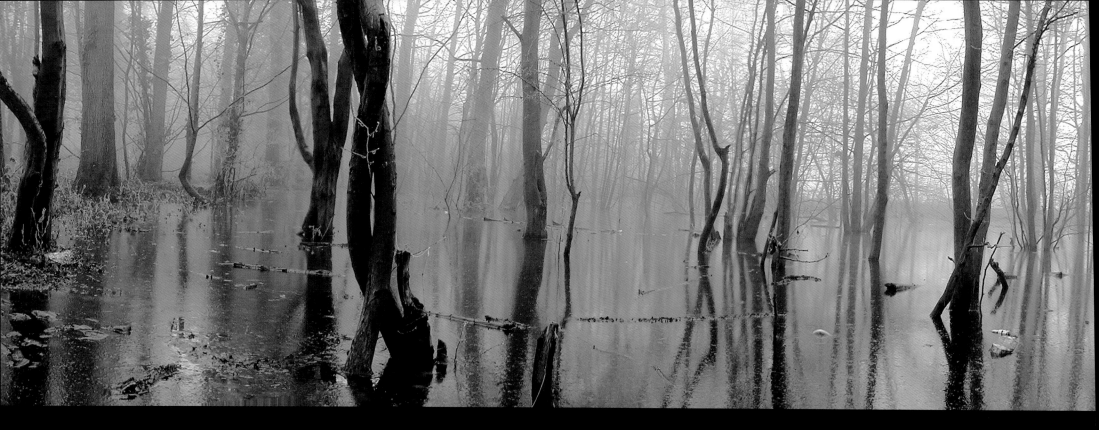

128

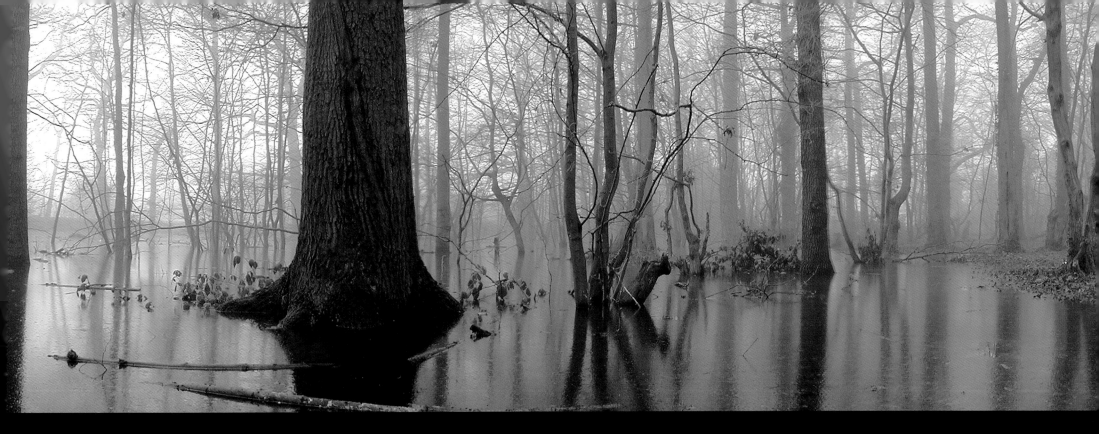

A difficult subject for a joiner, as straight lines do not often translate into a series of straight-line "joiner" images. The perspective lines would normally give away where the joins have been made.

Matt Chahal
Car Park
Nikon with aperture priority, Fuji Chrome slide film
© Matt Chahal

panoramic masters: michael westmoreland

Michael Westmoreland has been a photographer for thirty-five years, following his training as a sculptor and fine art printmaker in etching and lithography. His chosen subject matter for his panoramas is the built environment and the urban landscape. He has taken part in many exhibitions, still maintains an impressive client list, and has won several major awards. Like many people with an arts background, he has developed an individual slant on the visual world over a very long period of time. There is a continuity between the work he is doing now at the age of seventy, and the etchings he did as a twenty-year-old. Westmoreland is interested in working outside conventional format ratios

to an extreme where concerns such as composition become irrelevant. This is not a gimmick for its own sake: being free of the constraints of normal formats opens up a whole new world of linear subject matter, which he continues to explore with great originality.

The seeds of Mike's career were planted during a visit to the United States in 1965 where, for the first time, he saw the work of Elliott Erwitt and Henri Cartier-Bresson. The trip completely changed his ambitions as a sculptor and propelled him toward photography. He soon realised, however, that

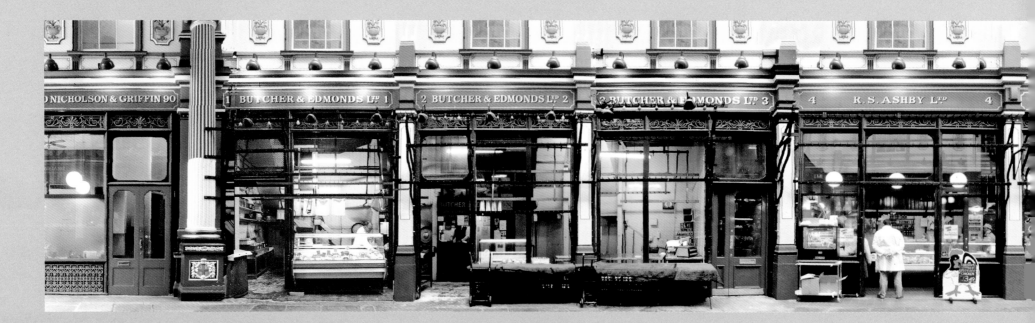

his 35mm camera was just not good enough for his intended purpose. He switched to a larger half plate (4"x6") camera, but was still not satisfied with the quality. He worked his way up through the format sizes until he laid his hands on a massive 12"x15" camera. Yet he still felt that he wasn't getting enough in his pictures and, after a visit to the Kodak museum in Harrow, England, hit upon the idea of using a Cirkut camera. His love affair with large panoramic cameras had begun.

Cirkuts have removable lens panels, which Michael realised would enable replacement of the old optics with superior modern lenses, especially the wider and longer focal lengths, but it took him nearly twelve years to track one down – ironically, just two miles from his home. He bought his second, a No.10 Cirkut, in such immaculate condition that he felt it was too pristine to use, and so in due course, he went on to own six others of various sizes. His favourite is the No.6, "about the size and dimensions of a brick". It shoots up to fifteen feet of film in one panorama and the hand-processing techniques are lengthy. It can take up to two hours hand-rolling the film through five-foot-long troughs, "an ideal source of dermatitis", so he does it less now than he used to. Michael is nothing less than pragmatic. "The problems that arise from creating panoramas make us into engineers in order to solve these visual conundrums." His 16"x20" enlarger is apparently a case in point, just one more inventive solution in his endless quest.

Michael has written his own chapter in the development of the panoramic image. In the early 1970s he had a vision of a quantum leap in the maximum size of a film image, and pioneered the use of Cirkut cameras with modern lenses and large rolls of colour aerofilm. "At that time, the largest size of conventional colour film was 8"x10", and 100 degrees was the widest feasible angle of view. I realised that it was possible to create colour film images ten or twenty times that size, which could not only shoot the full 360 degrees but also massively increase the information content of a single image" he explains. Although it had already been achieved with black and white film on Cirkut cameras, Michael realised that nobody else had been down such a road in the history of photography, and decided to pursue his dream of the Giant Colour Panorama. It took him about a year to develop the associated technology to turn his dream into a reality. His exceedingly costly panoramas were rendered on a unique transparency film used only by himself, and which will never be manufactured again. An interesting spin-off from this is that these panoramas make stunning contact-prints on archival Cibachrome colour paper, which are still in demand today. How he subsequently missed all the fame and fortune for his pioneering work is a long story, but he is still proud of his original technical achievements. In 1984 he was awarded the Richard Farrand Award, an occasional distinction conferred jointly by the Royal Photographic Society and the British Institute of Professional Photography, for original work in the field of Applied Photography.

Michael's intended audience is "the man on the street". His work has been displayed in many public spaces and he takes great pleasure from knowing that people can see it freely. He explains: "It is not generally realised how much the modern view is now constrained by the tyranny of media formats such as TV screens and magazine shapes. The downside of this is that the extremes of length involved in panoramas make reproduction (and hence publicity) much more difficult. Anything longer than 2:1 ratio doesn't get seen." Extreme panoramas can really only be appreciated on a wall, ideally on a corridor where the viewer must travel along the picture rather than try to assimilate it in one go. "The very largest pictures need some very large walls. Such walls do exist and are often in environments which could benefit from extended art. One thinks of places such as hospitals, airports, metro stations, restaurants, or indeed any public spaces where there is a captive audience".

Michael's favourite subjects are urban landscapes. Although he shoots 360-degree pictures, Michael prefers linear scenes. Picture editors often see the 360-degree format as a chance to flatten out a circular subject and have suggested taking a picture from the centre of Stonehenge to visually straighten it out. "It proves nothing" he despairs, "you end up with something that looks like a bearskin rug".

Since the Cirkut became too heavy for him to carry around, Michael has been using the much smaller Hulcherama, equipped with a 645 Mamiya shift lens. The updated model now features a built-in shift and a viewfinder window. With his age working against him, and in his efforts to keep weight to a minimum, he has also recently rediscovered the joy of the 35mm single-lens reflex camera. "It's easy to put in my pocket, so now I use a Nikon, a couple of 645 lenses plus a Zork shift adapter and a monopod". He wouldn't consider shooting without some kind of vertical shift lens, as the geometric alignment is essential for successful stitching later (with PanaVue Image Assembler) by computer. He has been amazed at the success he has had shooting sequentially with the Nikon, an irony he is quick to point out after all these years of carrying huge cameras.

These days, Westmoreland shoots panoramics mainly for pleasure, with the occasional commission. His most recent project was a series of linear reconstructions of street scenes and other urban "impossible shots". He has evolved his own methods for recording façades of buildings without being put off by visual blockages. To create these panoramas takes many hours, both at the shooting and stitching stage. Imagine trying to shoot a picture of a shop front with a parked car in front of it, and

now imagine shooting a whole street with all sorts of obstructions. The difference in scale, and sometimes lighting, is what he then collates magnificently into his street-front panoramas, for which he has won several awards. The patience and imagination needed are but two ingredients of this great pioneer's work, and we should all be astounded by his dedication.

PREVIOUS SPREAD
This view of all the shop fronts together can never be seen in real life, as the arcade is very narrow. This image is made up of many smaller images stitched together with the aid of Picture Publisher.

Leadenhall Market, London, UK
Nikon SLR, Digital Linear Reconstruction.
© Michael Westmoreland

ABOVE
Views such as this are inevitably blocked by parked cars and other obstructions, but Michael gets around this by shooting around the obstacles and stripping them into his digital montage.

Street scene, Leicester, UK
Nikon SLR, Digital Linear Reconstruction
© Michael Westmoreland

Reichstag, Berlin, Germany
(rotational panoramic of the new German Parliament commissioned
by the architect Sir Norman Foster and Partners)
Hulcherama camera with 50mm 645 shift lens
© Michael Westmoreland

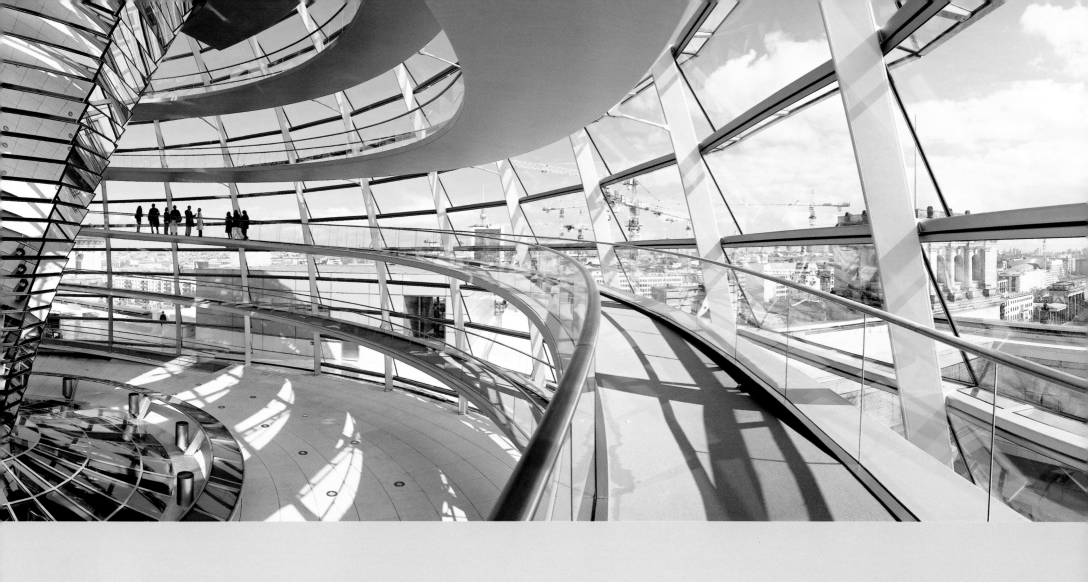

panoramic masters: professor andrew davidhazy

Andrew Davidhazy began his journey into the realm of panoramics in the 1960s, working in a chemistry lab on scientific applications for cameras. While working on his undergraduate photography programme, he came across George Silk's extraordinary distortion in *Life* magazine, described as "photos made with a camera modified to work like a Photo-Finish camera". He set about modifying a camera to do the same thing, and, through his discoveries, evolved towards panoramic pictures, leading eventually to what we now know as peripheral pans. He has also done pioneering work in other fields, and lectures on the principles of streak, strip and scanning photography. Strip cameras in general have been a great source of inspiration and satisfaction over the years, and he credits this work with being a significant factor in being chosen for the Kodak Visiting Professor award. He came to linear strip photographs while working on his masters degree, then started to publish his work, which opened many doors for him. He doesn't consider himself a panoramic photographer per se, being more interested in what happens when film is moved past a slit of light. He is constantly simplifying his approaches and is more interested in fundamentals, content to let others do the refining. He describes his contributions to photography as being more closely identified with those of a teacher and "improviser", though I would suggest his work is of great importance in the realms of pushing the boundaries of time and light.

A critical turning point for Davidhazy was a project initiated by the Dansk Corporation, who asked him to photograph some of their ceramics. They included the conical surface of a teapot, which in turn entailed various degrees of lateral thinking to calculate exactly how he should go about making a continuous strip photograph of a conical surface. At about the same time, his involvement began with the International Association of Panoramic Photographers (IAPP), where he'd been chatting with the "veterans" about their old Cirkut cameras and the focusing problems they'd been having when pointing their rotational cameras off axis and not producing sharp results. The physics were challenging, and it took him about a year to get the process underway. While driving his little Volkswagen along one day, he suddenly had the realisation that it could be achieved by moving the film in a circular, rather than in the traditional linear fashion. So he designed a strip camera that moved the film faster at one side of its recording slit than at the other. The pictures would turn out longer on one side than the other, hence the conical shape of the final prints. "Shortly thereafter, I rigged up my camera to make panoramic pictures and I deliberately introduced a significant amount of vertical tilt into the picture. The theory worked out perfectly in practice and the panoramic photographs showed no blurriness anywhere. Another somewhat unpredicted outcome was that although I already knew that the negatives this camera would produce were circular and that a given panorama would be recorded in a section of circle, it did not occur to me until later that the images created with this improvised camera would also provide me with a new way of seeing and interpreting the world as few others had done before". In Davidhazy's view, the standard (rotational) panoramic camera is "nothing more than a special case", capable of recording only cylindrical reproduction, whereas the conical camera is a whole new world.

Among many other fascinating ideas, he evolved his particular "pet" conical-panorama camera way before digital distortions became possible. He had been aware of pictures shot in the 1920s by a man named Mueller who had used a conical film plane, which he had tried to sell to the Army without success. Peripheral pan photographs evolved from these experiments. They were initially all shot on 35mm, ending up with six- or seven-inch strips, and printed using a four and a half by thirty-two feet enlarger, with a moving head, and in some cases moving paper too! In the 1970s, he made a vast 4.5'x32' circular print, from a 35mm original negative. It was suspended from the ceiling as a circle ten feet across, so that the viewer had to duck under it to get inside for viewing.

In his constant search for applications and visual solutions, Davidhazy has no particular preferences for types of format, or even for subject matter. Because he is rather more involved in solving particular processes, he prefers to find subjects that will fit in with his current projects. One of Professor Davidhazy's more challenging panoramic experiences involved shooting a continuous strip of film along a mile-long avenue in Rochester, New York, from a moving car. He was interested in the distance of the subjects from the film plane, and the anomalies of perspective reproduction, so he worked out a plan that showed the distance from the road of each building along the route, to register the buildings at their correct proportional size. It took him a while to work out the formula for slowing the film down for the buildings that were furthest from the road, and how much he should speed up for the nearest. The area between buildings had to change seamlessly with the speed. When the great day came, they set out complete with police escort and drove the mile-long avenue at speeds between 10 and 35 mph. As they approached each building, an assistant would shout out what speed should be attained, while trying to maintain the speed of the film with the changing speed of the car. It was all over in about ten minutes, then they turned around and shot the other side of the street too. The end result was a strip of 35mm film about twenty feet long, which he enlarged five times in a strip enlarger, where the negative and the paper both moved, to make a print about one hundred feet long of each side of the avenue. The print is thought to be still with the director of the Planetarium who commissioned it, but it is not known if it is has ever been exhibited.

ABOVE

"This was made in the mid-1960s as part of my work for an MFA degree in Graphic Design at RIT. Once I mastered linear strip photography, I saw the connection to peripheral capture and concentrated on this for the MFA thesis. The model sat on a turntable and presented changing features of her head to the camera and these were sequentially, but continuously, recorded by my self-built strip camera, fashioned by attaching a motorised rewinding system to a 35mm camera into which I had installed a fine slit at the focal plane."

LEFT

"A smaller scale version of the setup, which in this case was used to shoot a peripheral pan of a teapot for the Dansk Corporation."

Periport: Peripheral or "rollout" portrait photograph
Modified Canon 35mm SLR camera with 100mm Canon FL lens, Kodak Ektachrome film
© Andrew Davidhazy

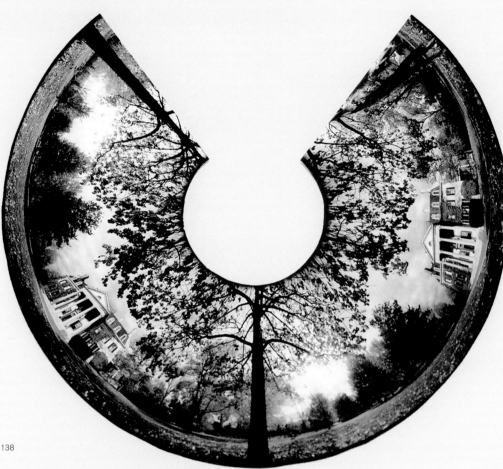

When working on his distorted peripheral portraits, Andrew makes the point that it's not always easy to get models to pose for him, knowing that he's going to deliberately distort their features. Instead, he auctions off "opportunities" to have a weird picture made. The person who modelled for the Hat picture won a prize auctioned on a local TV channel. The picture came about as he moved the camera while the subject was also moving – the result being a perfect composition.

When he's shooting new peripherals, he can only do a certain amount of previsualising: the speed of the subject, the recording rate, the angle of rotation of the film and many other factors can all affect the outcome, making it difficult to predict exactly any result, or even to duplicate the same experiment again exactly. He points out that although it is now possible to make similar imagery digitally, predicting precisely with this method is still difficult. "One can set up things to happen, but a fine level of prediction is still hard to do". Even harder to predict are his latest experiments, Peripheral Panoramics: panning the camera across the subject while it moves can produce a confusion of visual information, producing, for example, a picture of a man with three legs, introducing an unexpected factor to the picture. After everything else he's achieved, it should come as no surprise that Andrew Davidhazy has now also brought us the Surprise Pan...

LEFT

"Although this photograph looks like it was made with a fisheye lens, the presence of the building's facade in two locations around the picture circle is an indication that it was made with my special, circularly moving film, panoramic strip camera."

Circular peripheral photograph
Homemade circular strip camera
© Andrew Davidhazy

RIGHT

"This shot was made using the same method as on the previous page, except that, while the model rotated on the turntable, the camera was also panned so that its view extended away from the model on one side and again away from her on the other. During the exposure, she made a 180-degree turn and thus one of her legs appears on two sides of the photo, producing an unusual three-legged woman!"

Karen-cone, Peripheral or "rollout" portrait
Modified Canon SLR, 100mm Canon FD lens,
Kodak Plus-X film
© Andrew Davidhazy

140 Another shot made using the rotating turntable technique. As the camera panned from one side to the other, the model made a 180-degree turn – the back of her head appears on both sides of the photograph.

The Hat (Peripheral or "rollout" portrait)
Modified Canon, SLR 100mm Canon FD lens,
Kodak Plus-X film
© Andrew Davidhazy

"I used the circular strip camera to photograph a vase of flowers, which I had arranged in the vase to approximate the shape of a cone."

Rose, circular peripheral photograph
Homemade circular strip camera
© Andrew Davidhazy

141

contents

PHOTOGRAPHERS

Andris Apse: www.andrisapse.com
Everen T Brown: www.everen.com
Julia Claxton: www.ijules.com
Joe Cornish: www.joecornish.com
Andrew Davidhazy: www.rit.edu/~andpph
Macduff Everton: www.macduffeverton.com
Horst Hamann: www.horsthamann.com
Karen Kuehn: www.karenkuehn.com
Josef Koudelka (Magnum Photos): www.magnumphotos.com/Koudelka
Nick Meers: www.nickmeers.com
David Noton: www.davidnoton.com
Benjamin Porter: www.benjaminporterpanoramics.com
Henry Reichhold: www.reichholdarts.com
Mark Segal: www.segalphoto.com
Onne van der Wal: www.vanderwal.com
Michael Westmoreland: www.bigshotz.co.nz/mikewestmoreland
Alan Zinn: http://panoramacamera.us

CAMERAS and EQUIPMENT

Calumet Photographic: www.calumetphoto.com
KB Canham: www.canhamcameras.com
Fuji Film USA: www.fujifilm.com
Fuji Photo Film UK Ltd: www.fujifilm.co.uk
Gilde Camera, Germany: www.gilde-kamera.de
Globuscope: www.everent.com/globus/
Gran View Camera: www.granview.com
Hasselblad X-Pan: www.xpan.com
Hulcher cameras: www.hulchercamera.com
Linhof (UK): www.linhofstudio.com
Lookaround: http://panoramacamera.us
Kurt Mottweiler: www.cnsp.com/mdesign
Noblex: www.kamera-werk-dresden.de/english
PanoCam: www.spheron.com
Teamwork: www.teamworkphoto.com
TrueWide Digital Sliding Back: www.kapturegroup.com/true/wide
The View Camera Store, Inc. www.viewcamerastore.com
Robert White: www.robertwhite.co.uk

DIGITAL STITCHING

Stitching Software:
Adobe Photoshop: www.adobe.com
PanaVue Image Assembler: www.panavue.com
PhotoVista: www.roxio.com
Picture Publisher: www.micrografx.com
Realviz Stitcher: www.realviz.com
Furtwangen Panorama Tools: www.fh-furtwangen.de/~dersch
Panorama Maker: www.arcsoft.com
Panoweaver: www.easypano.com
Pixmaker Pro: www.pixaround.com

Stitching photo lab service:
ABC Photo & Imaging: www.imageabc.com
Big Photo Help: www.BigPhotoHelp.com

NEGATIVE AND TRANSPARENCY FILING

Javerette, UK: www.photosleeves.com
Secol archival sleeving, UK: www.secol.co.uk
Bair Mounts, USA: www.inkjetart.com/sp
Franklin Photo Products, Indiana, US: www.franklinphoto.com

PANORAMIC ORGANISATIONS

For information on all things panoramic: www.Panoguide.com
IAPP (International Association of Panoramic Photographers): www.panphoto.com
Panoramic Network, the Association for Panoramic Image Producers: http://panoramic.net
The Association of Photographers: www.the-aop.org
Panoramic Images, Chicago: www.panoramicimages.com

The author would like to thank all those photographers who have relentlessly pushed the boundaries of panoramic photography with their combined imaginations, and especially those who gave their time so freely in the making of this book – pure inspiration.

Thanks also to Doug Segal and his team at Panoramic Images in Chicago for their support, and access to the unique imagery in their phenomenal collection, sometimes at very short notice.
Thanks to my editors Nigel Atherton and Clara Théau-Laurent, and to Red, the designers who made it all work.

An enormous thank you to Trudie for her unfailing support throughout the (late-night) writing process, for listening, responding with positive feedback, and for looking after my body and soul as only she can.

...and thank YOU for buying this book.

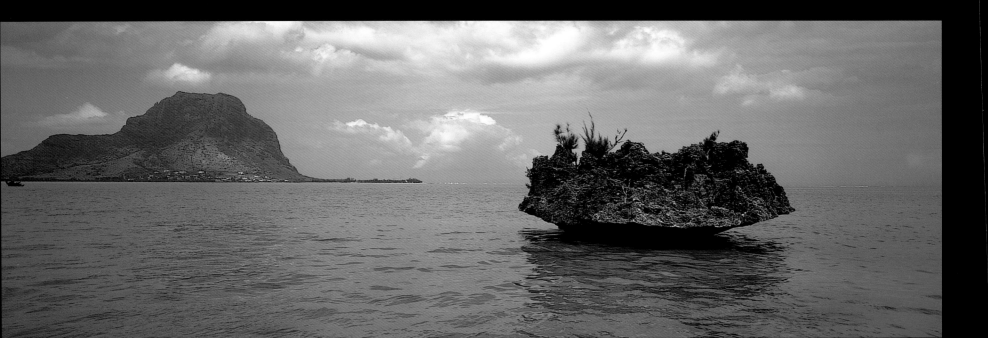